Storytelling
with Collage

techniques for
LAYERING COLOR & TEXTURE

Roxanne Evans Stout

NORTH LIGHT BOOKS

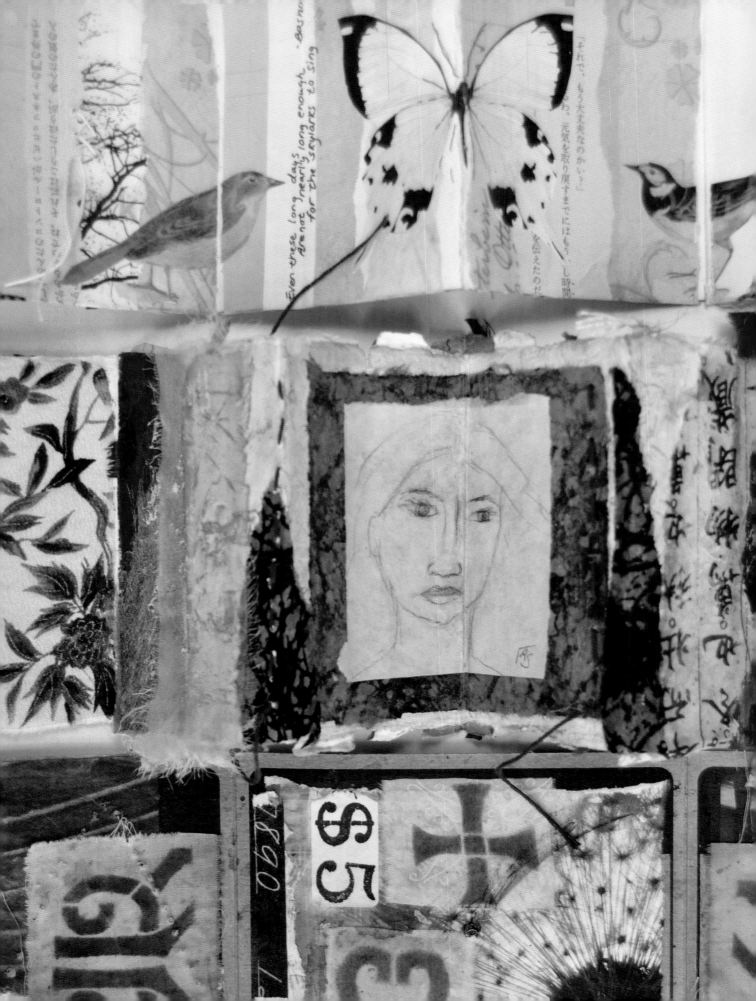

Contents

Introduction: Stories *4*

Materials
Storytelling Tools *6*

Chapter 1
Collage with Textured Papers *8*

Today on My Worktable . . . 10
Collage Challenge - Finding Balance 12
A Collage Story - Caterina Giglio 16
Windows on My World 18
A Collage Story - Crystal Neubauer 20
A Collage Story - Donna Watson 22

Chapter 2
Collage with Fabrics *24*

Today on My Worktable . . . 26
Collage Challenge - Morning Poem 28
A Collage Story - Elizabeth Bunsen 32
A Collage Story - Mary Ann Lehrer-Plansky 33
Windows on My World 34
A Collage Story - Lorri Scott 36

Chapter 3
Collage with Stitching *38*

Today on My Worktable . . . 40
Collage Challenge - In Only a Day 42
A Collage Story - Sharmon Davidson 46
Windows on My World 48
A Collage Story - Annie Coe 50
A Collage Story - Jane LaFazio 52

Chapter 4
Collage with Found Objects *54*

Today on My Worktable . . . 56
Collage Challenge - From This Land 58
A Collage Story - Seth Apter 62
Windows on My World 64
A Collage Story - Rebecca Brooks 66
A Collage Story - Robyn Gordon 67

Chapter 5
Collage with Photos and Images *68*

Today on My Worktable . . . 70
Collage Challenge - The Cornerstone 72
A Collage Story - Orly Avineri 76
Windows on My World 78
A Collage Story - Sarah Fishburn 80
A Collage Story - Joanna Pierotti 82

Chapter 6
Collage with Nature *84*

Today on My Worktable . . . 86
Collage Challenge - Rise up to Meet the Sun 88
Windows on My World 92
A Collage Story - Kim Henkel 94
A Collage Story - Bee Shay 96

Chapter 7
Collage with Color *98*

Today on My Worktable . . . 100
Collage Challenge - Gowns of Golden Grace 102
Windows on My World 106
A Collage Story - Ro Bruhn 108
A Collage Story - Stephanie Hilvitz 109
A Collage Story - Tracy Verdugo 110
A Collage Story - Jill Zaheer 112

Chapter 8
Collage with Wax *114*

Today on My Worktable . . . 116
Collage Challenge - April Rains and These Days 118
Windows on My World 122
A Collage Story - Bridgette Guerzon Mills 124
A Collage Story - Mary Beth Shaw 125

Chapter 9
Collage with Metal *126*

Today on My Worktable . . . 128
Collage Challenge - Inside a Butterfly's Dream 130
Windows on My World 134
A Collage Story - Karen Cole 136
A Collage Story - Leslie Marsh 138

Index *140*
About Roxanne *143*

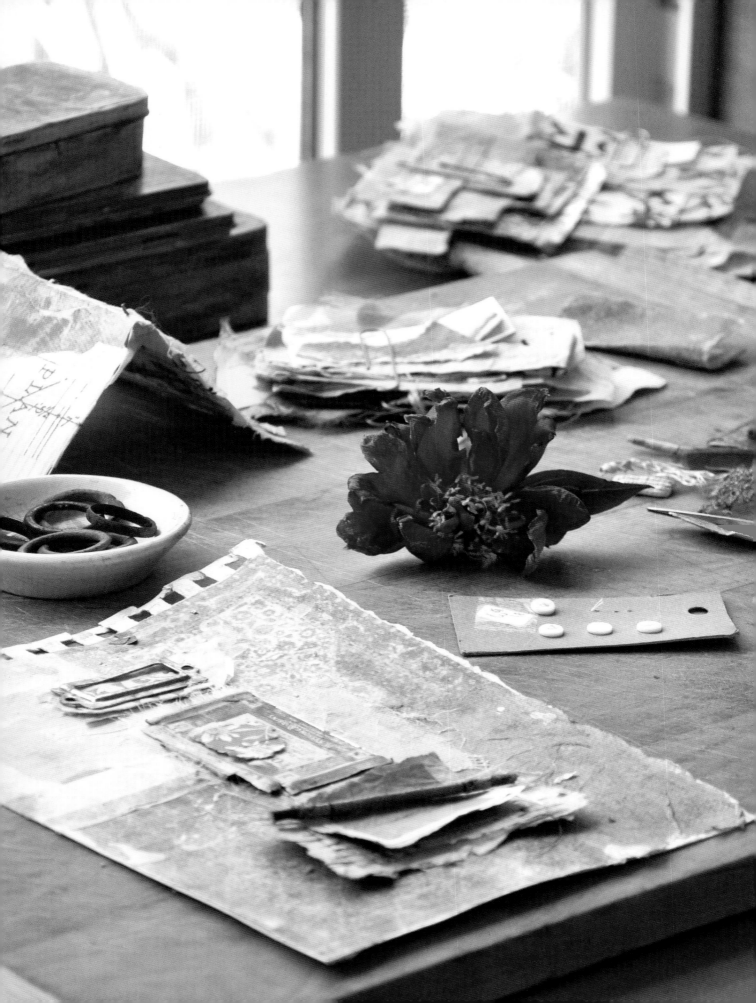

INTRODUCTION
Stories

...........................

The journey between who you once were, and who you are now becoming, is where the dance of life really takes place.
»» Barbara deAngelis

I have often thought that every piece of art has a story. Sometimes the story is in my imagination long before I create a collage, and sometimes it emerges much later.

This book is a collection of my own collage stories and those of other artists. I would like to invite you to experience each of these Collage Stories, not only by viewing the artwork itself, but by reading each story written from the hearts of the artists themselves.

My wish is that when you look at each photograph of my world, my worktable or the collages and stories that you may be more inspired in your own life.

Storytelling Tools

On these pages I want to share with you the general materials we'll be using to create collages throughout the book.

Adhesives

I have often called matte medium my favorite tool, and I talk about it a lot in this book, especially in chapter one.

- acrylic matte medium
- craft glue
- GAC 200
- gesso: white and clear
- glue sticks
- mosaic glue

Cleanup

I have a couple of different water dishes I use; one is smaller for painting with watercolors. The other (it was my mother's—a square plastic dish, stained and discolored, and I am quite attached to it) is larger and is used for collaging. It needs clean water more often as it gets thick with gesso and matte medium fairly quickly.

- hand sanitizer
- paper towels
- water dish
- wipes

Color & Marks

There are so many materials that you can use to add color, tints or backgrounds to your collage pages. Pan-Pastels are my favorite. Their colors are soft and earthy, and you can make them transparent or opaque according to how you apply them. Hair spray is a great fixative for pastel and doesn't smell as strong as the fixatives you buy in art stores. (TreSemmé comes in travel-size spray bottles.)

It is good to have a variety of paintbrushes, some for details and some for backgrounds.

- acrylic paint, assorted colors
- distress Inks
- PanPastels
- pencil, no. 2 with a good eraser
- permanent pens
- pigment inkpads: black, brown and white
- watercolors

Encaustics

These are the materials and tools I begin with when I want to add beeswax to my collages. If you decide to do more advanced work, there are books and websites that can help you expand your encaustic workstation. I talk about collaging with wax in chapter eight.

- beeswax, white
- heat gun
- old paintbrush or ½"–1" (13mm–25mm) crafting brush
- palette knife
- small Crock-Pot

Found or Collected Objects

You might be surprised by what you can find in your own backyard or garden. These are things I love to collect that work well in collages.

- baling wire and rusty wire from the garden
- beach glass
- beads
- buttons
- chain
- discarded candy bar wrappers
- flat stones
- leaves and other natural treasures
- old paint chips
- old pocket watch parts
- old tickets, tape, price tags
- pieces of text
- rusty washers
- seedpods
- shells or shell fragments
- small vintage bottles
- small vintage tin boxes
- wine labels

Imagery

If you are reading this book, chances are you already have a stash of images that you've collected—either your own photographs or torn from magazines or discarded books. Hold on to them! You never know when you might need one for your collages.

- newspaper, magazine or catalogue pages
- old hankies, scarfs or fabric napkins
- photocopies of fabrics or rugs
- pressed flowers
- printed-out images of your own photographs or copyright-free images from the Internet
- stamps
- stencils
- vintage postcards, books, envelopes and letters

Papers & Fabrics

I love paper and fabric too; the more unusual the texture, the better. Paper can be found at paperies and art supply stores, and vintage papers (and fabrics) are often in antique stores and on Etsy.

Fabric stores will have cottons, muslin and silk as well as tapestries and upholstery fabrics. Here are some of my very favorites:

- cheesecloth
- cotton
- envelopes
- fabric scraps
- graph paper
- handmade papers
- lace
- mesh
- mulberry paper
- muslin
- Nepalese paper
- old library cards and pockets
- paper scraps
- rice paper
- silk
- tissue paper
- velveteen
- vintage fabrics
- vintage paper
- wax or parchment paper
- wrapping paper

Stitching & Attaching

For binding books and even stitching as an embellishment I often use beading cord. It comes in many colors and is easy to thread into a needle.

Wire can be found in many sizes and colors. I suggest experimenting until you know what works best for you.

- beading cord
- embroidery thread
- metallic threads
- twine or string
- wax linen thread
- wire, assorted gauges and colors

Surfaces

I use all of these surfaces plus many others, but my very favorites are old scraps of wood. My husband and my son often build things, and anything left after their projects are complete is fair game for me.

If I am using a canvas board, I prefer the wrapped ones but will use anything I can get my hands on.

- art journal
- canvas board or wraparound canvas
- watercolor paper, various sizes and brands
- wood scraps, square or rectangle

Tools

I keep all of these tools handy. My favorite straightedges are the old wooden ones. I like their simplicity and the feel of wood in my hands and am always on the lookout for them in antique stores and on Etsy.

I use all sorts of cutting tools, but as you will see throughout this book, I prefer tearing my papers. Sandpaper is a must to roughen up old tin and wood pieces and also images from magazines that are too glossy.

For attaching found objects to pieces of wood I use small nails and tacks. I like to dab a bit of acrylic paint on the heads if they need to blend in a little more.

- awl
- brayer
- drill, small bit
- hair dryer
- hammer
- jumbo paper clips
- needle-nose pliers
- sandpaper, fine, medium and rough grades
- scissors
- small hammer
- small nails, brads and tacks
- straightedge or ruler
- tapestry or large-eyed needle
- utility knife
- wire and metal cutters

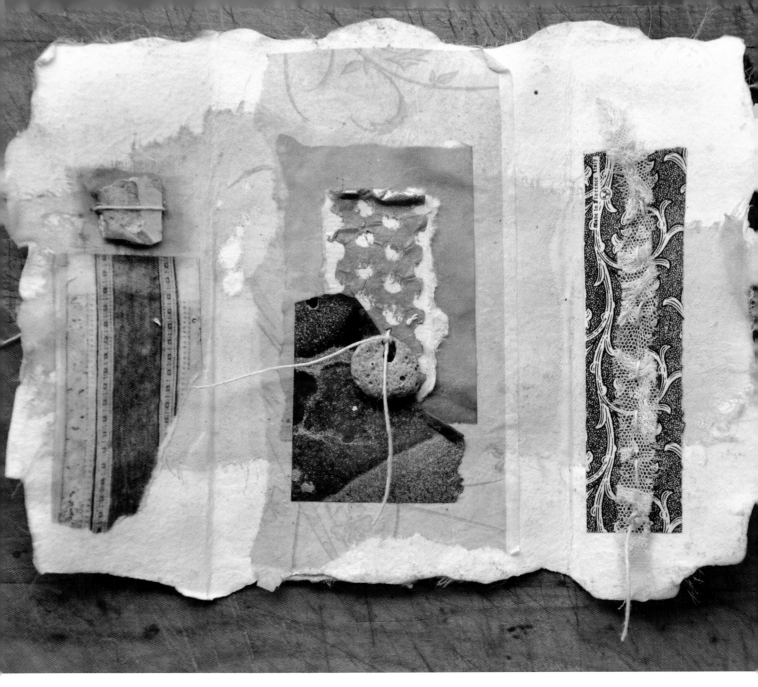

MOONRISE

In the midst of a hot and dry summer I was driving back from having my work shown at an opening in Jacksonville, Oregon. The sky was filled with dramatic thunderclouds, and below them a huge moon was rising, a "super" moon that we see here only once in a long while. I thought of my home a few hours away. The moon was rising there over the Klamath River as well, watching over my family and everything else that I love.

Collage *with* Textured Papers

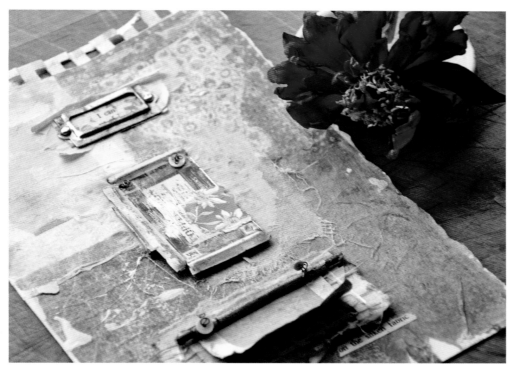

Respond to every call that excites your spirit.
»»» **Rumi**

this chapter you will discover different ways to use your papers by overlapping, tearing and cutting. You will learn to use your intuition and trust your instincts. And you will discover the freedom to explore in new ways!

Collaging will give you a chance to play, a chance to experiment with texture and color. When you create a collage it becomes your story. Often it emerges slowly, or sometimes it is there from the beginning.

In this chapter, you will see how I begin my textured paper collages and how laying out papers and objects on my worktable inspires me to create. You will be introduced to my home, the views from my windows and the nature that surrounds me.

And you will meet three artists whom I discovered several years ago from blogging and have loved ever since. You will see for the first time their textured paper collages and read unique collage stories that they have created just for this book. You will experience firsthand their unique style and how they find beauty in the smallest details.

When I discovered that I could use different papers—especially rice papers—in my artwork, a whole new world opened up to me. This discovery and making collages changed my life as an artist.

I had ordered packets of colored rice and mulberry papers, and when they arrived I joyfully experimented with them for hours. I loved learning how some of the papers changed color with the matte medium, and how some were transparent and some were opaque or became darker. I began to notice that choosing my papers helped me set the mood and tell a story.

I found myself collecting papers wherever I went. Torn paper towels and napkins that I had found in restaurants, parts of paper bags and discarded colored tissue paper left over from holidays all filled my baskets. Soon I had boxes and baskets filled with them, all different sizes and colors. I love to share these papers at my workshops and have many baskets of them filling my studio shelves.

To me, collage is so much more than just covering a page with random papers or images, although that is certainly fun to do. A collage is the story of this moment in time. Creating one is full of surprises. As you read through

Things to Love About Textured and Colored Papers

- The way they feel to the touch—rough, smooth or somewhere in between.
- The way they change colors when they are next to another color.
- Some are transparent and some are opaque.
- They all have a different sheen; some are dull and some are shiny.
- There are always different papers to be discovered.
- When you collage with papers, you can play with design before even putting a mark down on your paper.

Today on My Worktable...

The artist is a receptacle for emotions that come from all over the place: from the sky, from the earth, from a scrap of paper, from a passing shape, from a spider's web. »»» **Pablo Picasso**

There is a quote that I found in a home decorating magazine, "Surround yourself with the things you love," by designer Bob Timberlake. This quote has come alive in my studio and especially on my worktable. When I begin a new project I start by laying out the tools I will use. These are often tools that have been handed down from my mother, who was an artist as well, or that I have found in antique stores hiding in the bottom of old, dusty boxes.

Next I lay out things that give me inspiration for the project: colored and textured papers in small piles or bundles, an old photograph or book, a poem written on a scrap of graph paper, my most recent vintage finds or small collections.

And perhaps one of the most important things is that I love to go outside into my garden and collect a small arrangement of flowers or leaves. I will put these in a dish of water or just lay them out to dry, finding beauty in all of their stages. These arrangements give me a sense of belonging and connecting to the natural world, and they help me remember to always find beauty in the details. In these examples I am sharing with you some photographs of what is on my worktable at different times.

Task

What small things do you love that you keep on your desk or worktable? What are your very favorite art tools? Take a moment to really look at them, take a photograph or write about them in your journal. Where did you find that stone, or who gave you that special paintbrush? What are your favorite colored pencils or paintbrushes that you find yourself using again and again?

Make a group of them and take a photograph of your arrangement. This itself is a collage.

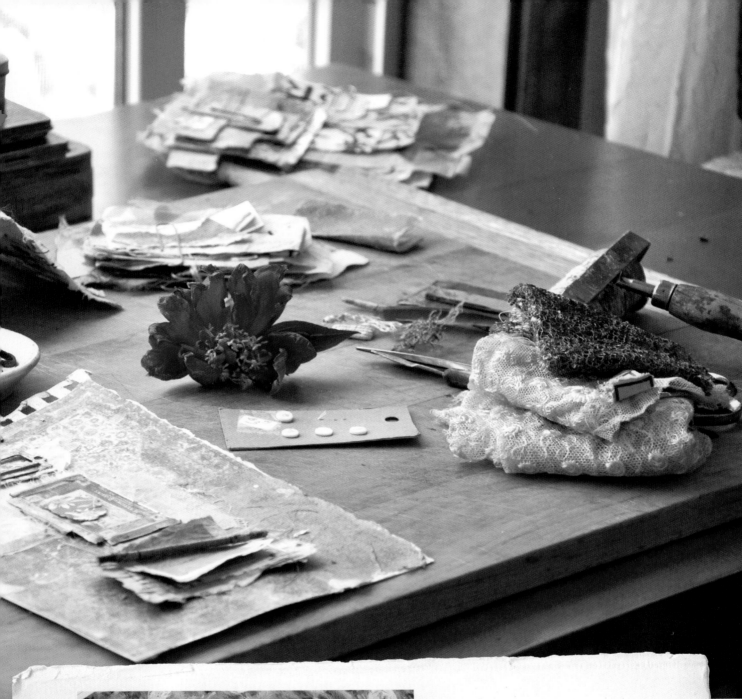

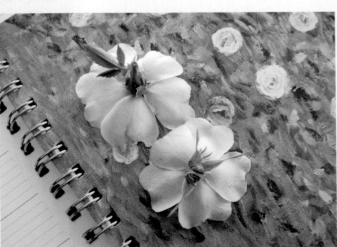

Task

Bring leaves or flowers in from your garden or a nearby park. Lay them on your desk or art table near a current journal page or collage. Take a photograph. Press them and use them in your art later. (I press leaves and flowers in whatever book or journal I have nearby. You don't need a plant press.)

COLLAGE CHALLENGE
Finding Balance

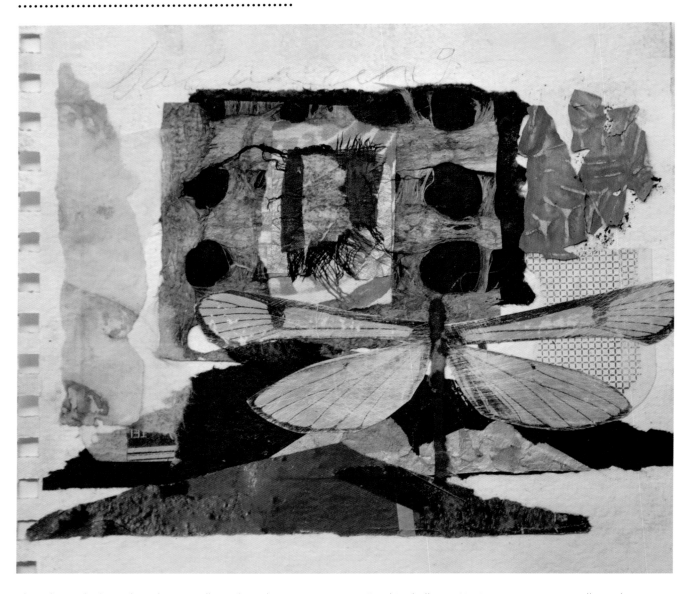

I have been thinking about how we all need to take time to balance our lives. Sometimes one thing can take over your minutes and your days, but even though it is something you love, you realize it is time to spread your wings and make time for other things in your life. Maybe you need to slow down a little and focus on all of your gifts, not just one. To get more fresh air, read a favorite book or dance to your favorite music. This is just what I have been going through.

My collage is a metaphor of finding my own balance between traveling and staying home, between teaching and creating my own art, even between working in the garden and being in my studio. In *Finding Balance* I experimented with textures, with darks and lights, with smooth and rough surfaces, and with ideas and themes.

For this challenge I invite you to create a collage about finding your own balance. Naturally, there are times when deadlines and responsibilities loom. But when they are finished, what helps you slow down and pay attention to the things that are important to you, as well as the things that need to be done? As you work on this collage, can you find a balance between darks and lights, textures and patterns, colors and images? Just as you create a balance in your artwork, you can create a balance in your life just by giving it some thought.

What You Need

- brayer
- Distress Ink Pad (Tim Holtz)
- images for focal point
- matte medium
- old paintbrush for using matte medium
- paper towels
- papers for collaging (assorted textures/colors)
- pale blue hard pastel
- paperclips
- parchment or wax paper
- pencil
- sandpaper, fine
- straightedge or ruler
- water dish and old brush
- watercolor paper, 140-lb. (300gsm)

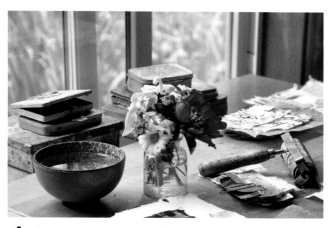

1 Set up your workspace

Before you begin, find an area where you like to work; under a window works great, especially when the sun isn't shining right in. I chose my desk under an east-facing window that faces my front yard. Here I am using an old butcher block as my surface. In the background you can see part of the large window in front of my desk. I love to decorate and alter vintage tins, and some are stacked on the back of my desk. Also shown are flowers from my garden, a water dish, small bundles of papers and an old brayer.

2 Gather your papers

Gather papers together and bundle them with other papers that are pleasing to your eye. Paper clip your bundles together; these could be in bundles of similar colors, contrasting colors, or darks and lights. Give yourself lots of choices and try photographing them as I did. Be true to yourself and how you feel on this day; on another day your collections could be very different.

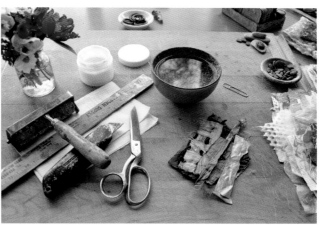

3 Gather your tools

Gather up your favorite tools. You can see my brayer, straightedge, box cutter, scissors, matte medium, a water dish and parchment paper. Leaving a space in the middle of your worktable for your collaging is important, although for me it becomes messy in no time!

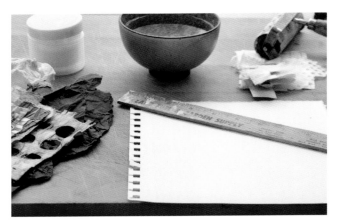

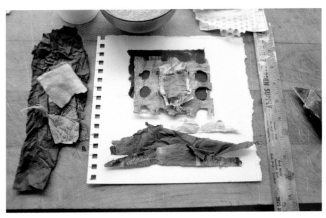

ᔭ Tear your paper

Cut or tear your paper to about 8" (20cm) square. To tear, lay the wooden ruler on top of your paper, lining it up evenly with the sides. Holding the ruler firmly, pull up from the top right side and tear. This makes a nice, soft torn line. You can also paint a strip of water along the ruler where you want to tear. This softens up your edge even more. Using this process to trim your papers instead of using scissors to cut them adds an interesting edge to your work.

5 Lay out your design

Begin to lay out your collage. Here some of my papers reminded me of mountains and land forms, so I decided on an abstract landscape for the foreground. Above it, almost in the center, I wanted to make a window with different papers showing through. What shapes are your papers, and do they resemble something? Which forms call to you more than others? Experiment with overlapping, tearing and layering the papers you've chosen in different ways until you have a design that you like.

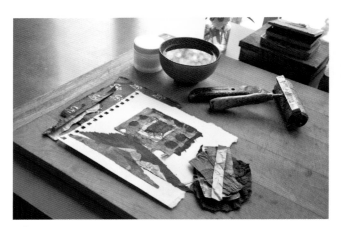

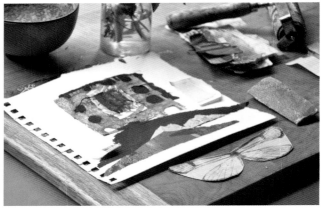

6 Adhere your papers

Begin adhering your papers down. Start by moving your design over to the left side of your worktable and, taking the bottom piece first, glue it down with a layer of matte medium underneath it and then over it. Sponge off the excess with a paper towel, then use your brayer to get out air bubbles. Use a piece of parchment or wax paper over the collage to protect it and roll in different directions.

ᔭ Choose and adhere your focal point

This step can be omitted if you feel your collage does not need any other elements. While your collage is drying (you might want to weight it down for a few hours under books), search through your photos or images from magazines and find a picture of something that might look good as a focal point in your collage.

I chose a moth image from an old *National Geographic* and cut out the wings, leaving some of the background. Sanding magazine paper adds an interesting scratchy quality to the front, and sanding the back side helps magazine images adhere better. I usually don't sand photocopied images because they stick well and lighten up anyway when I use matte medium.

Adhere your focal point and any other pieces to your collage using the same method as you used in your collage.

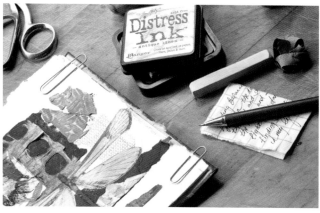

8 Add interesting details

Add final details to your finished collage. Before you adhere anything else down, lay it on your collage to make sure about its placement. In my finished collage you can see that as well as my moth wings I added a few other papers to the sides of my collage. I made the body of the moth from a piece of blackish paper and lightly drew some antennae.

Tint your edges using Tim Holtz's Distress Ink or a pastel. I also used a pencil to lightly scrawl *balancing* over the top of my collage. If there is a word you are thinking of, write it somewhere in your collage with a pencil.

Task

Go on a paper treasure hunt. Gather everyday papers from your house: a napkin, a paper towel, a piece of corrugated cardboard, text from a newspaper, colored images. Add some vintage text, notepapers or parts of sheets of music.

Play with arranging them on a piece of watercolor paper. When you like one of your arrangements, begin gluing it down with matte medium. Step back and look at your collage from a distance. What colors or textures stand out? What colors did you use? And what do you think of when you look at it?

Tips on Using Matte Medium

The two brands of matte medium I use are Liquitex and Golden. Liquitex is slightly thinner than Golden and less expensive. Mod Podge also works well if you get the matte finish, but it is glossier than the other brands.

I always use the same process when I am using matte medium to adhere the pieces of my collages. Something to remember is that thinner papers take less matte medium than thicker papers, and sometimes a glue stick might be necessary.

Here is my process:

1. Dip an old paintbrush into water, then blot off excess on a paper towel.
2. Using matte medium, paint a layer under your collage paper and over it. (If you have something in the wrong place, you can pull it up and move it still.)
3. Blot with a paper towel. If you leave too much matte medium over your work, it can look milky.
4. Repeat this process as you build up your design.
5. Roll over your collage periodically with your brayer. Use a piece of parchment paper to protect your collage. This will get out any air bubbles and help secure your papers.
6. Always rinse off your brush completely, or leave it in your water dish. Matte medium can ruin brushes, though I have discovered that soaking a hardened brush in hand sanitizer can get it clean.

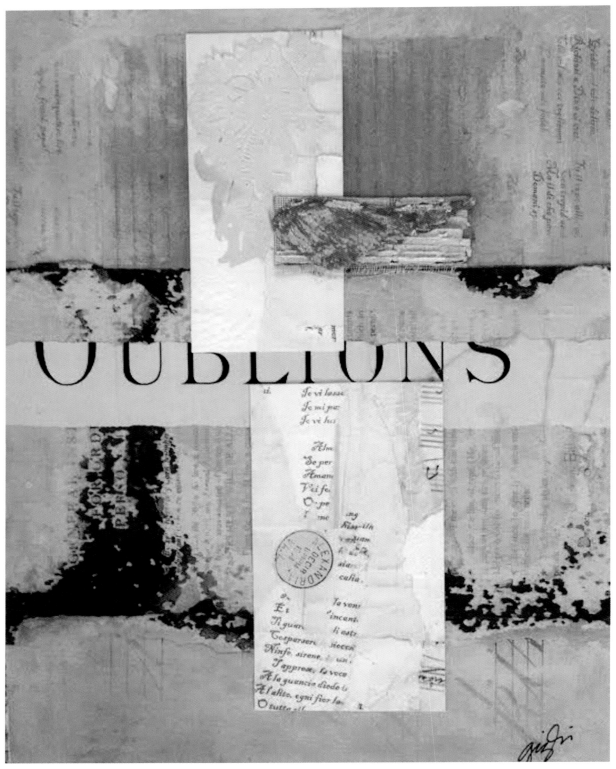

Rising Above It All
12" x 9" (30cm × 23cm)
Italian collage, acrylic paint, walnut ink, acrylic glaze, antique papers, antique wallpaper, book
pieces, antique paper bird wing, gold leaf, cardboard, decollage, pastels on cradled board

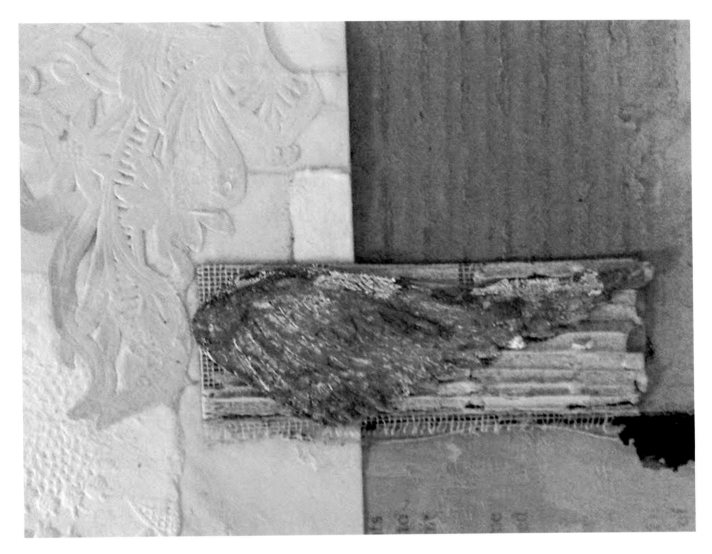

Friends often give me antique books or scraps of ephemera. So it was with this tiny wing from a torn piece of embossed wallpaper. The wing, long separated from the bird. My friend was dealing with the early stages of Alzheimer's, yet she had the memory to give me this tiny piece of cellulose.

In constructing this mixed-media painting, I also had the fortune of finding a piece of paper with the French word *oublions*, which translates to the word *forget*. I was quite touched by my friend and her gift and reminded myself that I would one day use it in a piece that not only felt like a tribute but served as a reminder that no matter what is happening in our lives, or what chaos we find ourselves in, we can choose to see beauty, to look for the rainbows and to rise above it all.

To me, Caterina's collages are an expression of her joy in the creative process, and I love discovering how she composes each of her pieces. Please visit Caterina's blog at caterinagiglio.blogspot.com.

Windows on My World

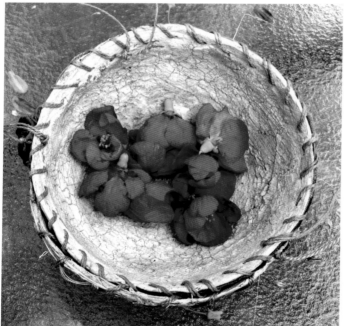

When I am inside, especially at my studio desk, I can see out of the large picture window that faces east to our gardens in front of our house. My home is so important to me. Over the years my husband and I have landscaped our whole property, and the half acre has been like a huge canvas to me. I still find little plastic animals and Legos where the children had their forts under the aspen trees.

We have a deck that goes out from my studio, and I love to sit out there in the morning sunshine.

As I write this, the birds are singing and the greens are still pale and bright These are the first greens of spring.

I am constantly noticing how the view changes from one window of our house to the next, and even from one day to the next as the trees leaf out and our house becomes more and more a shady oasis, a sanctuary for my small family.

Back when my children were little, our gardens were also a sanctuary, a world filled with adventure and trails through the tall flowers and gardens.

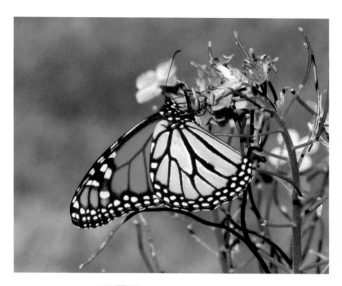

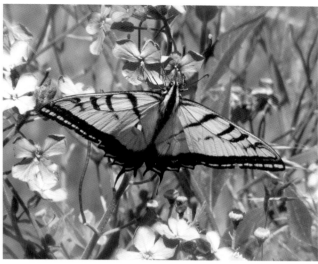

Those who don't believe in magic will never find it.
»»» Roald Dahl

In the spring we have an abundance of swallowtails, but it is unusual for us to have so many monarchs, especially when they are right outside my window on the same clumps of flowers! Of course I had to take another garden break with my camera when I saw them.

Note to Self

Be open to discovering small moments of magic.

When we were up visiting my son in his little college town, I found a wind chime in a sweet little boutique and thought it would go perfectly in my back patio garden. The mobile had beautiful orange and green beads hanging from it, and I loved its playfulness. I decided to hang it right from my yellow garden umbrella. Later on that same afternoon I sat at the table looking up at it and marveling at the shadow play of the light streaming through the branches of the maple tree above. I tried to capture the light and the playfulness of this wind chime in this photograph.

Task

What plays of light or flickering shadows are magical to you? Take time to write about your discoveries in your journal or to photograph them so they are forever remembered.

A COLLAGE STORY
Crystal Neubauer

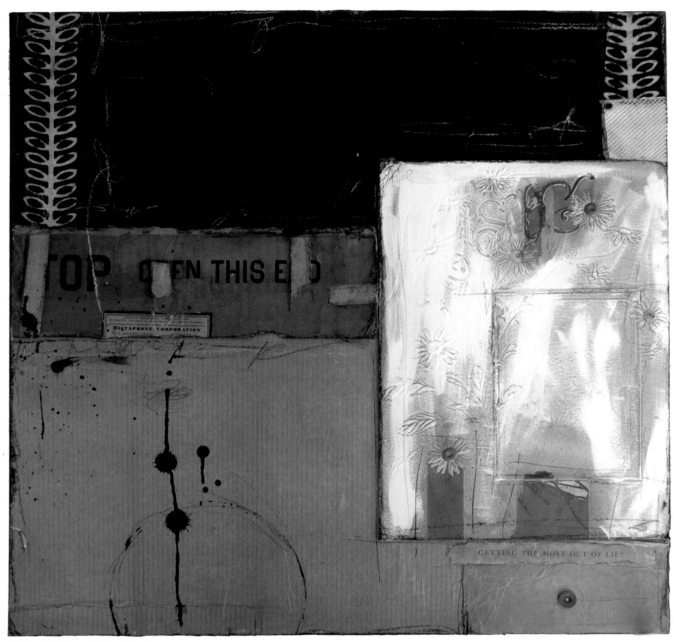

Oh Death Where Is Your Sting?
24" × 24" (61cm × 61cm)
Salvaged book cover, salvaged book board, salvaged paper bag, salvaged change purse, handmade paper, India ink, graphite, charcoal, acrylic paint, 140-lb. (300gsm) cold-pressed watercolor paper, paste on cradled panel

GETTING THE MOST OUT OF LIFE

Often, I limit the distractions when working in my studio. No TV, computer, Facebook, phone or even music. Everything is silent except the thoughts swirling in my mind. As the collage begins to unfold in front of me, these thoughts make themselves known by the scraps and bits coming together on the canvas. Sometimes I will hear a story developing. It is in the form of a verse or a line from a song or the words spoken by a friend repeating over and over in my head as I work. I will know what the story is even before the collage is done. Other times I have to live with the piece for a while. Set it up against the wall and leave it alone. Walk in and out of the room a few times in order to see what it has to say to me. A lightbulb will go off and I'll know that I know.

As the composition began to form in this collage, I came across the spine from a book jacket with the title *Getting the Most Out of Life*. I knew it was supposed to be a part of this collage, but it took me a while to find where it fit. As I moved the scrap around I saw the connections forming between it and another element, the old antique box top that read "Open This End" that simply begged to be interpreted as opening the door to truly living life to the fullest. And then there was the salvaged book board with its remnants of flowers from the cover still attached. I saw this as an offering, a bouquet where each petal was an adventure of that life fully lived.

In spite of the story happening in such an overt way in front of me, it took me a while to come up with the title. It seemed trite to use any of the words written in such an obvious way. Then one day as I walked into my studio I looked at the collage and immediately heard it: "Oh Death Where Is Your Sting?"—a line from a popular worship song—and knew this was it. It isn't just in the knowledge that this life isn't the end that takes the fear out of death, but in really and truly getting the most out of living each moment. Staying present in the day, no matter how mundane it may seem. Seeing the divine in ordinary simple tasks. In the knowing that you absolutely left nothing on the table when challenges came your way, but faced them square on, then really, death, where is your sting?

Crystal has a way of finding beauty and creating beauty in the way she arranges her collages. You can see more of her work at crystalneubauer.com.

A COLLAGE STORY
Donna Watson

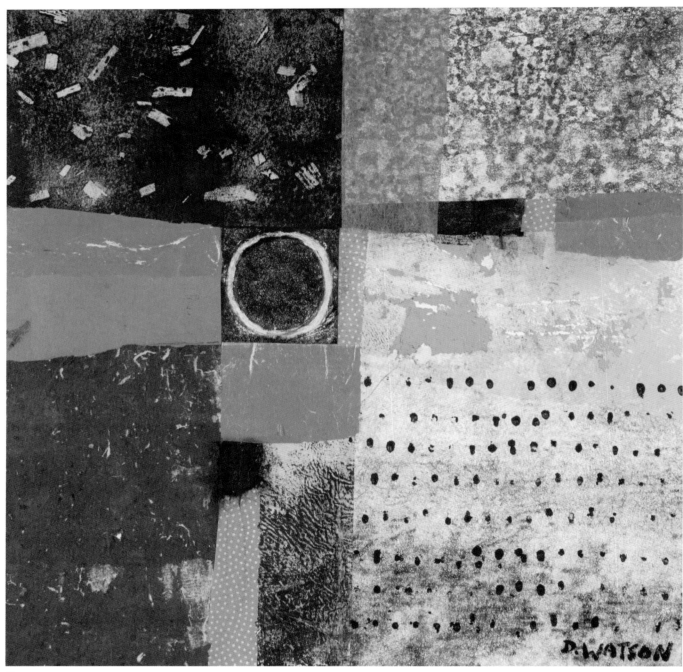

Enso
10" × 10" (25cm × 25cm)
Rice papers (various types including Tengucho), acrylic paint, matte medium

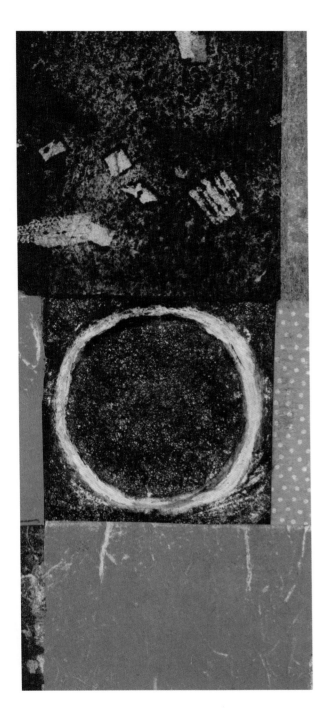

My heritage is Japanese. I have been fortunate to travel to Japan twice since 2009 to visit the temples in Kyoto along with some very huge temple flea markets. I also have studied Zen tenets such as *wabi-sabi*, which have influenced my collages. *Wabi-sabi* is the Japanese art of impermanence and imperfection in which one seeks the transient beauty found in nature.

Wabi-sabi is a beauty of things incomplete, modest, humble, weathered, worn, torn and textured, as happens with the passage of time. This brings us to another Zen tenet involving the circle, or *enso*. In Japan, the circle represents the cycle of life: Life begins, grows, disintegrates and begins again. *Enso* fits in the *wabi-sabi* philosophy of incomplete and impermanent.

Boro is immersed in Japanese cultural history. Beginning in the 1600s, poor Japanese commoners were permitted to only wear clothing dyed blue, brown, gray or black. Cotton was a luxury item. Fragments of worn-out garments were sold or handed down to the poor, who pieced and patched these fragments into their layered clothing and futons. These tattered, worn garments, once scorned, are now national treasures.

When I saw these patched and quilted fabrics at the temple flea markets, I knew I wanted to try to replicate the same textures and patterns using paint and paper. I call this my *"boro* influence." I experimented with different rice papers and acrylic paint and have come up with textured rice papers that I use in my collages. My hope was to come up with textured papers similar to the *boro* fabrics I saw in Japan. I included the *enso* in this collage as well. With the passage of time, there are textures, layers and traces left. The cycle is never ending. This is what I hope to convey in my collage.

Donna creates beautiful and sensitive collages out of seemingly plain materials. You can see more of her work at donnawatsonart.blogspot.com.

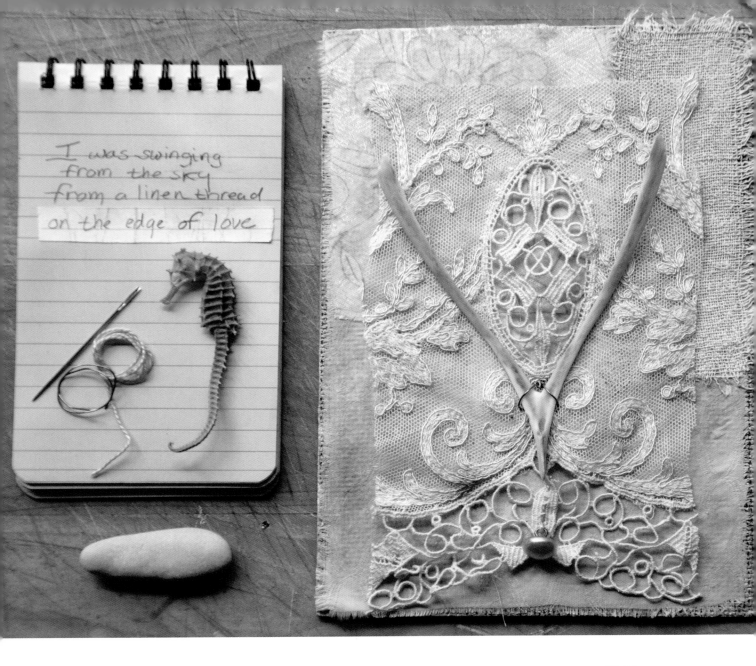

I was swinging
from the sky
from a linen thread
on the edge of love

SWINGING WITH THE SEA HORSE

When I was in my early twenties and I couldn't get to sleep, I would imagine that I was swinging from the sky on a large wooden swing fastened by two long, fraying fabric cords. At that time I was living in a little college town in northern California that sat on the edge of the forest looking over the Pacific Ocean, and from my imaginary swing I could see down into the forest and the ocean. Swinging back and forth would always fill me with wonder at the beautiful sights below me, and I was lulled to sleep.

The little poem at the left was made up of words grouped together in an activity inspired by the poet Susan Wooldridge, who was visiting me with some other friends for some writing and art in the garden. The sea horse represents the ocean; the stone, the subtle wearing down of time and the little pearl button represents the gifts I have to share.

Collage *with* Fabrics

What art offers is space—a certain breathing room for the spirit. »» **John Updike**

I love using fabric as a background surface and as smaller elements of color or texture in my collages. When I was growing up, my mother would make me lovely dresses for holidays and every fall for the starting of school. Each detail from a little button to a bit of embroidery on a collar was entrancing to my little-girl eyes. My mother's sense of design and color was apparent in everything she did. On Saturdays we would go shopping together, and my favorite place other than the huge old bookstore downtown was an old fabric warehouse a few blocks up from the Santa Monica Pier, where one could find huge spools of material unlike anything in the smaller fabric stores. The feel and the smell of fabrics are still things that I love.

Do you have special memories of the fabrics from when you grew up? A tapestry rug, lace curtains, a wool blanket or a handmade shawl or dress? What do you remember about them?

When I first started to use fabrics in my collages, I used them as background surfaces. I discovered that with the simple act of painting a layer of medium or clear gesso onto a piece of linen or muslin I could create a beautiful surface for a collage. I also learned that leaving the edges partially uncovered or just using the medium on the underside helped the original texture of the fabric show through.

Very thin or vintage silk makes a great textural surface when adhered to paper, canvas or wood. And transparent gauzy fabric can be wonderful to lay over an image or a pressed leaf to soften or protect it. Patterned scarfs are beautiful in collages—cut, torn or photocopied—and can give a sense of another time or culture.

Have you ever thought of adding fabric to your collages? Or using fabric in the pages of your books?

In this chapter I will show you how to create a collage with fabrics on a block of wood. I will introduce you to my favorite fabrics and those that I decorate my home with. You will be looking inside the windows to my home and my world. And I will introduce you to three artists who use fabrics in their art in unique ways.

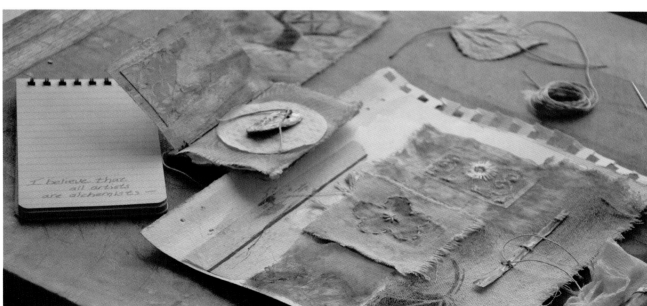

Today on My Worktable...

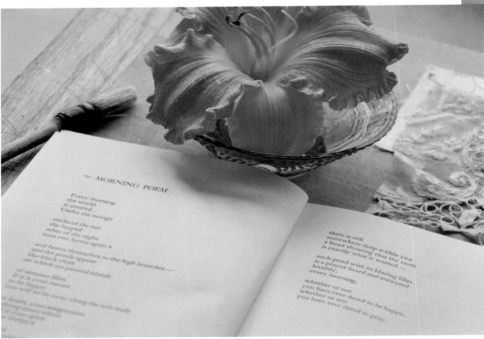

A little brass compact filled with vintage buttons, gifts from my sister.

A small twig that will someday find a home in a collage.

A stone, a delicate feather.

A shell fragment.

A yellow leaf on an old paintbrush.

A piece of a print of Laura Ashley fabric cut out of a book.

Beading cord.

A print of one of my stencils on transparent fabric.

A little book with fabric pages and one of my beliefs: that all artists are alchemists in one way or another.

A little box I made out of copper, small beach stones from the Oregon coast and a bolt found outside a seafood restaurant. This little box will be assembled as part of my Collage Challenge next in this chapter. In chapter three you will also see how I use the blue Laura Ashley print.

One day I picked an orange lily and took it into my studio so I could enjoy it while I worked. By chance, I opened a Mary Oliver poetry book and this just happened to be the poem I opened it to. I kept it open while I worked. This poem is called "Morning Poem." I named my new collage after it. To me, this poem captured the feeling of midsummer and how with a new day anything is possible.

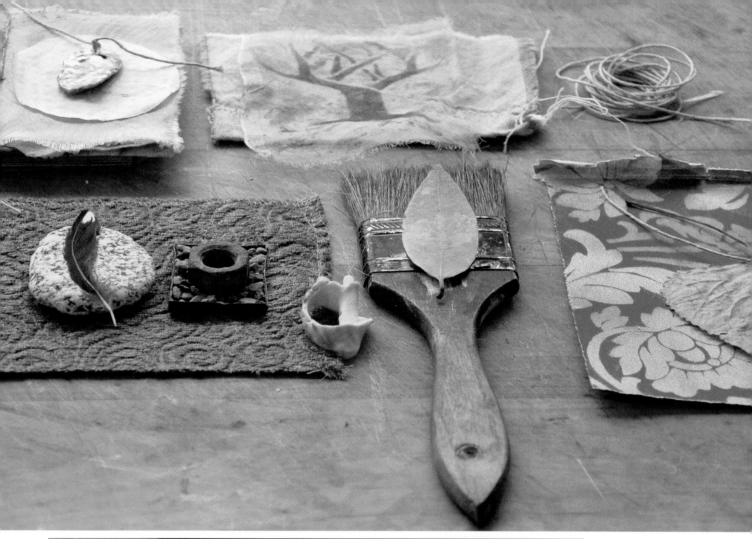

Morning Poem

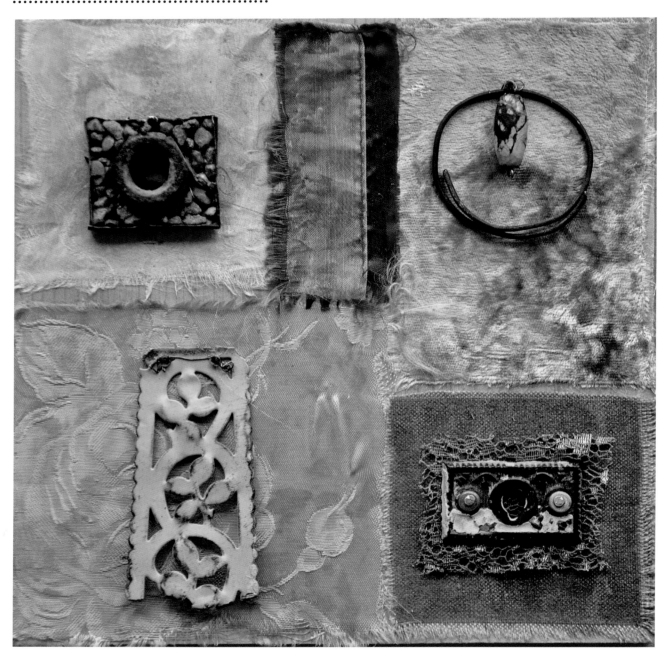

On summer mornings the sun comes into the large studio windows across from our bedroom and fills it with green-gold hues that light up the projects on my worktable. I always go into my studio first thing in the morning, even before my cup of coffee, a perfect way to start my day. I like to see how my projects look in the morning light and review what I will be working on that day.

This collage is made from scraps of fabrics, small pieces of my life that all hold a memory or special meaning. Over the top of the fabric background I had attached objects that tell me a story of beach stones and copper, baling wire bent into a circle, a vintage keyhole and remnants of a garden ornament. These objects are all different but all connected and beautiful in their simplicity.

When you begin this challenge think about mornings—the light and how it comes through the windows, the colors and the potential that a new day brings. By using textured fabrics and found objects, you will be telling the story of your own morning.

What *You* Need

• •

adhesive (matte medium, clear gesso or GAC 200)

brayer (optional)

fabric or lace scraps

found objects, small

hammer

nails, small

old paintbrush

paper towels

sandpaper, medium

scissors

water dish

wire (or cord or thread)

wood scrap, about 6" × 6" (15cm ×15cm)

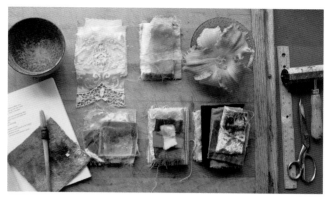

1 Gather your fabrics and supplies

Look through your drawers or baskets for fabric scraps that captivate you. If you don't have a collection of fabrics, go to a local fabric store. Most fabric stores will let you purchase even an eighth of a yard of their materials. Antique stores (the "junkier" the better!) and secondhand stores are also wonderful sources. Look through their piles of vintage scarfs, napkins or hankies and find some that you would like to use in your collages.

Using sandpaper, lightly sand your piece of wood. Clean off your worktable and assemble your supplies.

Tear scraps of fabric into different sizes, and pile them into different color and texture combinations.

2 Play with fabric layouts

Play with moving around your fabric, tearing or trimming pieces until they fit into a design you like.

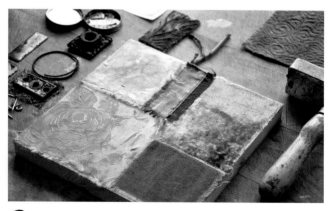

3 Adhere your fabric

Adhere your fabric to the wood, applying adhesive to it with an old paintbrush. Let some of your edges remain frayed and adhesive-free. Use lighter amounts on the lighter weight fabrics like silk, gauze or lace. Blot off excess medium with a paper towel.

A brayer can be used to smooth out bubbles and to help with adhesion.

Note: Always clean your brush thoroughly or soak it in your water dish when you are finished with your mediums or are between more involved steps. I have ruined many paintbrushes when I forgot to do this!

In an "emergency," soaking your paintbrush in hand sanitizer can revive it somewhat.

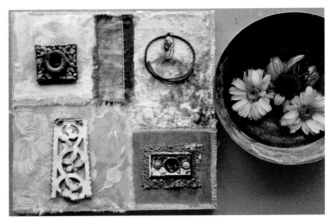

4 Lay out your objects

While your fabric collage is drying, search through your supplies for interesting embellishments or focal points. A small shell or twig could work, an old button, an image or part of a photograph that calls to you.

5 Secure your objects to the wood

Add your focal points. For images and lightweight fabric or paper, use matte medium, but for heavier objects use a hammer, small nails and wire or cord to adhere the objects. A heavier glue might also work to help hold them in place. When you are finished attaching your objects, think about what story this collage tells you.

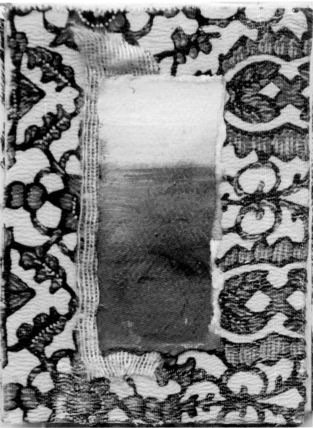

These are the front and the back of an accordion book made with vintage Japanese kimono fabric. I made this little book as a sample for a workshop called "The Art That Binds Us Together." To teach it, I received a grant from the Oregon Cultural Trust. This workshop was to go hand in hand with "The Art of Survival," an exhibit at a local museum that told the story of the Japanese American Internment during World War II. This very moving exhibit told the story of the human need to create and survive even in the hardest of circumstances and of the power of creating art.

Note to Self

Lately I have been thinking about this question: Who is the artist inside of me? One afternoon I got out a writing tablet and began to write these words:

There has always been an artist inside of me. I think there is an artist in all of us, just waiting to find a chance to be discovered. The artist who plays with vases or glass bottles on a windowsill, the artist who buys that unusual scarf or tablecloth and hangs it on a wall or drapes it across a table, or the artist who writes poems about the first day of spring or lists about the flowers in a garden. The artist who collects sticks and stones and loves them as much as a piece of jewelry or a beautiful ring.

Some of us have already discovered the artist inside ourselves and embraced him or her. We joyfully spend moment after moment playing with line and color and design, we love our art tools and are always on the lookout for a new way to express ourselves. We stitch and mold and carve and build layer upon layer. We embrace the happy surprises that happen on a journal page or canvas. And we joyfully create.

The artist inside of me is a creator, a teacher, a gardener and a nature watcher, a writer of journals and stories, an alchemist, a painter and illustrator of her world. She is passionate about creating, determined, unstoppable. She loves to experiment and record her days with photographs, the written word and art making.

The artist inside of me blooms and grows and thrives in my home on this river land, where the meadows meet the mountains, where the waterbirds fly and the north wind blows from far down the canyons and kisses my cheeks through my open studio windows.

There is a quote by Pablo Neruda that speaks of how I feel about this land where I live. Although I have been an artist all of my life, this is where my art came alive. There is something in the air here, on our perch at the edge of the mountains and above the river. Something that stirs my imagination and makes my heart sing.

"I grew up in this town,
my poetry was born between the hill and the river,
it took its voice from the rain,
and like the timber,
it steeped itself in the forests."

Task

How has your home and the land or city that surrounds your home contributed to who you are? Who is your artist inside? Have you discovered her or is she still hiding? Get out a pad of paper and write down your thoughts. This is your story.

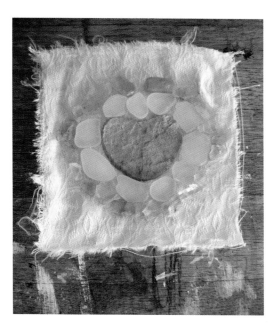

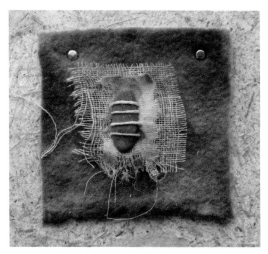

Elizabeth Bunsen

· ·

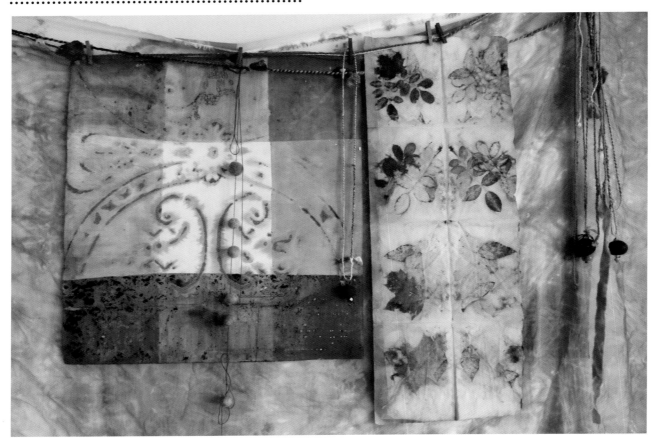

Happiness Medicine Wheel
60" × 36" (152cm × 91cm)
Layered installations using rusted, eco-printed, doodled, rose- and indigo-dyed fabric, paper; hand-twined string and clothespins

once upon a time
there was a girl who lived by a lake
whose pockets gathered seedpods and stones
dancing barefoot in moonlight was her habit
sunshine sparkling through laundry gave her delight
she sang with the wrens
the crows called her by name
clouds shared their secrets on her walks
one slow and quiet day
she circled
round and round and round
then
a bluebird dropped a feather
a feather striped with sky and sea
and tipped with a piece of the moon
of course
this feather found her pocket
the girl smiled
and dreamed a dream of blue

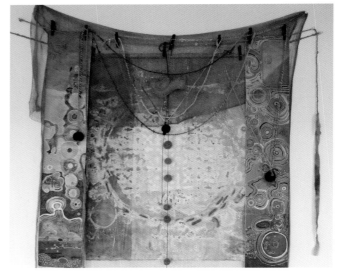

Elizabeth's art holds a magical light that seems to come from the slanting sun and moon reflecting off the lake waters of her home. Find out more about Elizabeth at elizabethbunsen.typepad.com.

Mary Ann Lehrer-Plansky

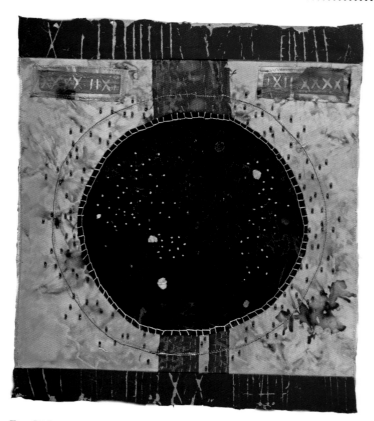
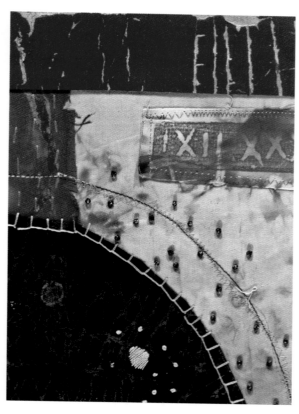

First Light
18" × 15" (46cm × 38cm)
Cotton cloth, hand- and embroidery-stitching, flour-resist treated cloth (black and wine), rust-resist treated cloth (beige), hand-stamped Roman numerals, copper glass, assorted beads, muslin, rose-red mottled cloth (found piece)

First Light is a result of an ancient teaching that describes sacred light as so dazzling that one could gaze on it from one end of the universe to the other. I was inspired by these words and began this piece by adding together each cloth fragment to create my take on this ancient view. The center circle (portal) is pieced together with veined black cloth with added gray glass beads and embroidery stitching. The surrounding fabric is a rust-resist treated cloth and has an outer circle of machine stitching with a scattered spray of copper beads to give the effect of an explosion. The two Roman numeral tabs are machine-stitched archeological catalog numbers. The top and bottom trim of wine-and-gold marked cloths were stitched from a more magical recorded time. Holding this sphere in balance are three mottled rose-red cloths that are heavily hand-stitched in rust thread. My art intends to create questions, wonder and light.

Mary Ann's work has intriguing elements of textures and patterns and a wonderful sense of history and storytelling. Visit Mary Ann's blog at blueskydreaming-sc.blogspot.com.

Windows on My World

Although my artwork is often muted and pale, in my home I love to decorate with fabrics, pillows and pottery from different cultures. These often have a colorful floral theme to them. I have these scattered around, even on shelves and cabinets, as if they were paintings or pieces of art, which to me they are! These rich colors brighten up my world and reflect in the windows and mirrors.

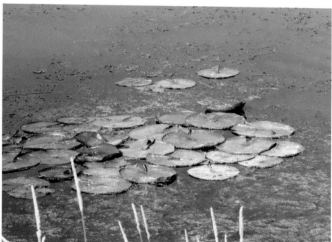

My summer garden is lush and green, and the flowers are the same rich colors that I have in the house. This is the time when exuberant flowers have burst open and before anything has gone to seed. The richness and diversity in each different area of my gardens is wonderful to see. At this time of the year even the river is rich with water plants and lilies.

There are two ways of spreading light: to be the candle or the mirror that reflects it. »»» **Edith Wharton**

Lorri Scott

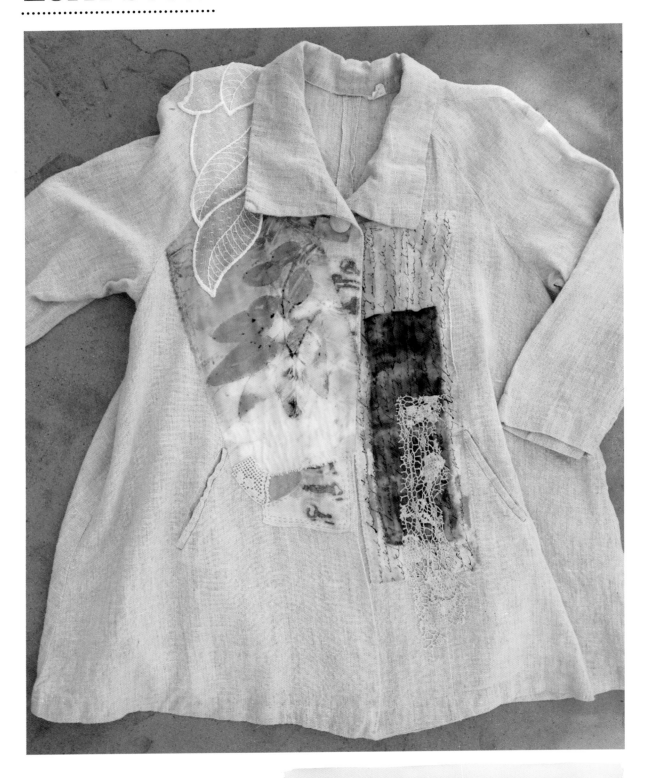

Lorri hand-dyes all her fabrics and combines them in beautiful and unique ways. Visit her blog at lasfibers. blogspot.com.

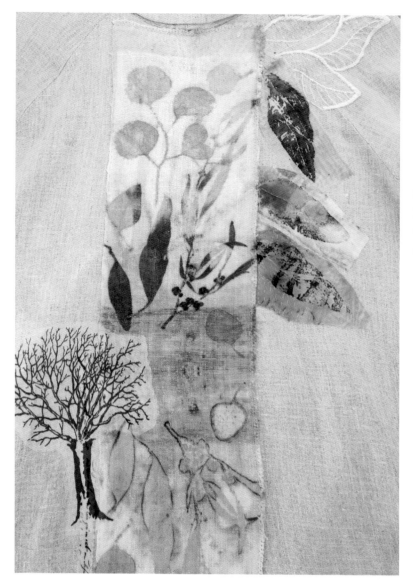

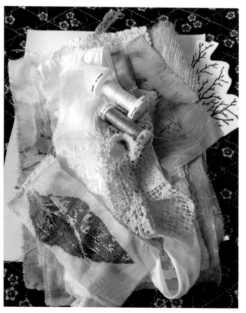

Melody of Piece
32" × 24" (81cm × 61cm)
Linen jacket, silk fabrics, vintage lace pieces, sewing thread, eucalyptus leaves and iron pipe dye, fabric paint, ink-jet printed onto organza

Fabric collage is like writing a visual song. Hand-dyed printed pieces are the notes, silk noil with faux writing the verse, and layering and piecing is the melody.

Hand-stitching it all together becomes the harmony. There is no fusible webbing used, no sewing machine, only a needle, some thread and a bit of dreaming. "Slow cloth" comes to mind, a term that indicates gentle stitching and implies a meditation in imagery.

Dye prints are made from leaves gathered on walks and rusted iron relics displaying a natural earthy color palette. Adding a bit of lace and other hand-dyed and hand-painted pieces creates a sense of completion.

A song is written from nature; can you hear it?

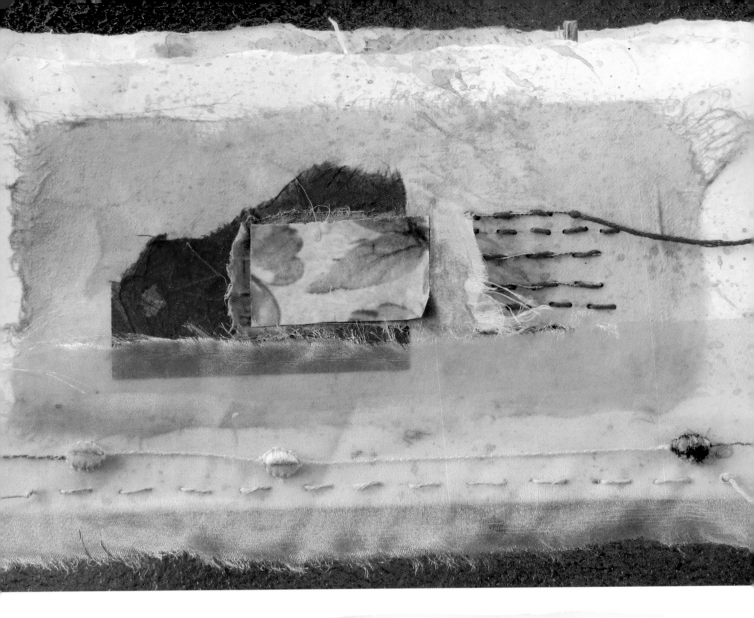

LATE SUMMER MAGIC

One day, late in August, I created this collage for the cover of a handmade book that would later remind me of the last days of summer. These were the days that were still long, but the sun was lower in the sky, and the grass in the fields had become pale. What do the days before autumn symbolize to you?

For me, the burgundy-red paper I used is not only the color of my hollyhocks but symbolizes strength, a boldness to stand out and be admired. The light green contrasts with the red as a softer beauty, both to the eyes and to the touch. The scrap of flowered paper is one I have had forever, just waiting for the perfect home. Other scraps included here are torn silks, gauzes and papers, some that I have stained or dyed myself.

I usually use the running stitch in my collages. I love the way the threads weave in and out, over and under the paper, connecting one image to another. There is a Japanese word for this simple stitch called *sashiko*. This stitching was historically used to strengthen and reinforce clothing or quilts, but can also be an elegant embroidery or art form. *Sashiko* patterns tell the story of Japanese culture.

CHAPTER 3
Collage *with* Stitching

Stitching by hand makes me think of a simpler time. The process itself is such a quiet and solitary form of art. When I stitch, my mind wanders and my thoughts become calmer. I slowly relax. I notice that my breathing becomes more even, and I can feel the beginnings of a small smile on my face. When I'm stitching I am transported to another time, and my memories and imagination are intertwined.

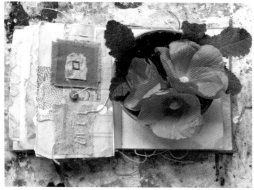

When stitching over a collage, I am remembering how I created it and retelling its story to myself. Sometimes I even stitch over some of my writing or words from a favorite author.

When you are stitching, does your mind wander? Does your breathing become calmer and is your world more peaceful? When you stitch, do your problems seem to not be so overwhelming?

Adding hand-stitching to a collage adds a tactile quality that is personal and unique. This stitching, whether subtle or dramatic, can pull your eyes around your creation and add movement and a lovely human quality to your work.

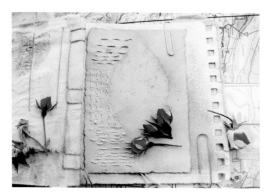

I like to add stitching to my collages last, when the piece is dry, and I usually draw the line or shape I want to stitch first with a pencil, then poke the holes with my awl, and then sew, carefully, one stitch at a time so the paper won't tear. To me, just as every scrap sewn on a quilt or used to repair a piece of clothing tells a story, so it is with each scrap in a collage, and stitching adds to its beauty, strength and complexity.

Today on My Worktable...

Summer is the time when one sheds one's tensions with one's clothes and the right kind of day is jeweled balm for the battered spirit.
»» **Ada Louise Huxtable**

On this day I lay out several things to inspire me on an old butcher block that has been in my family for ages. Sometimes I need more than one work surface to work on! In the top left corner is a small clump of library cards I got at our local library that will one day become part of a collage or used in a workshop. I stained them with sepia ink and tore them in half (a light acrylic glaze would work well, too). On top of them are small bits of paper and fabric. I love using graph paper in collages and there is a scrap here.

Next are wires and thread and beading cord, old buttons in shades of white and cream, an awl and two different sized needles. In the right-hand corner there is more thread and a little collage with a sewn leaf over the top of it. I sewed this in the car once on the way to a workshop in Whidbey Island in Washington state (I love to stitch in the car when my husband is driving).

Below the wrapped leaf is a rust-dyed butterfly image stitched with golden thread and the words demanding my attention. In the center bottom of this photograph I included a small book that I have slowly been filling up with collages, a woven leaf shape, an old button and a eucalyptus leaf that a friend sent me from Australia. This photograph below shows the finished pages with scraps torn and frayed and stitched by hand.

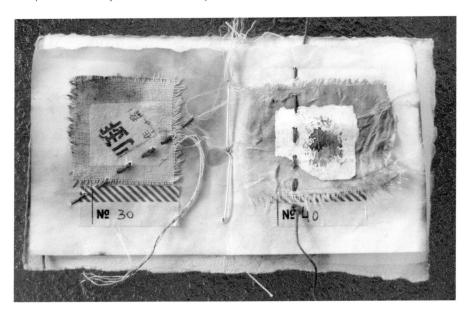

These are the things that demanded my attention. I believe that it is important to notice the little things as well as the larger things that make up your world. The smallest details can find a place in your art.

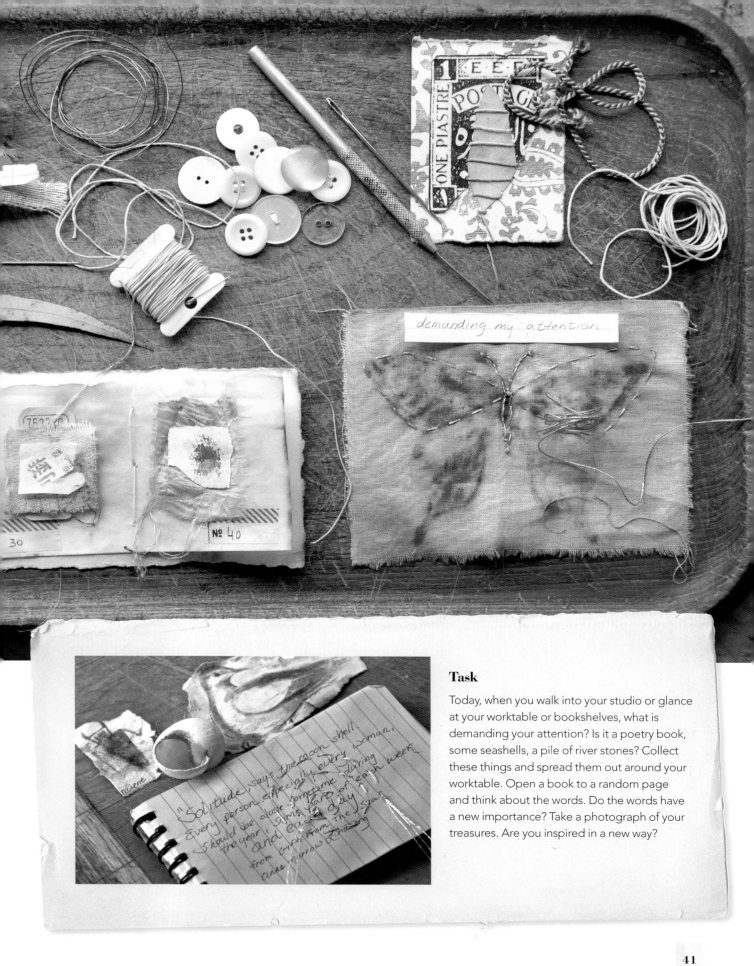

demanding my attention

No 40

Task

Today, when you walk into your studio or glance at your worktable or bookshelves, what is demanding your attention? Is it a poetry book, some seashells, a pile of river stones? Collect these things and spread them out around your worktable. Open a book to a random page and think about the words. Do the words have a new importance? Take a photograph of your treasures. Are you inspired in a new way?

In Only a Day

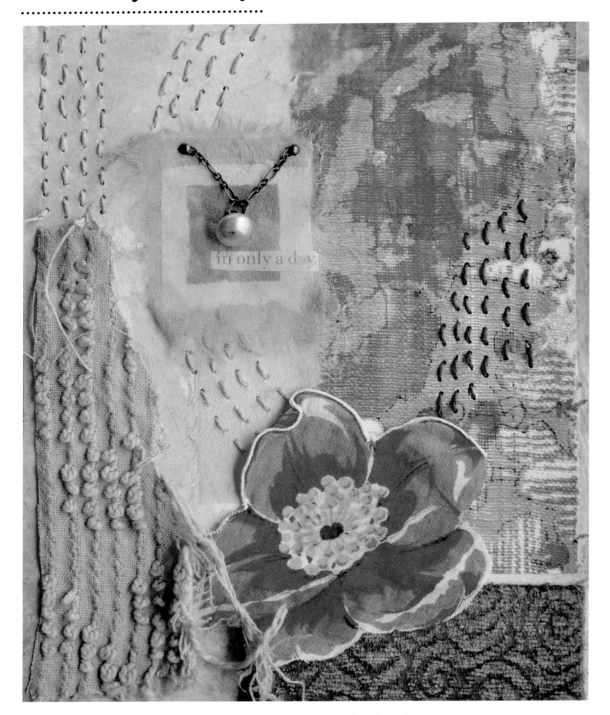

In only a day you can accomplish so much: You can create something brand new, rearrange your studio and see something that you didn't notice yesterday. In only a day you can write a poem just for yourself, plant some flowers or make a pot of soup. In only a day you can change someone's world by encouraging him and recognizing his light.

This collage is filled with the anticipation of waking up in the morning with a smile on your face and watching your whole day unfold.

What You Need

- acrylic paints
- awl
- beading cord or embroidery thread
- fabric scraps, some vintage
- glue stick or craft glue
- large-eyed needle
- matte medium
- old paintbrush
- paper scraps (the pink and green paper behind the flower is a photocopy of one of my scarfs)
- text, found objects, treasures from nature, etc.
- watercolor paper, 140-lb. (300gsm)

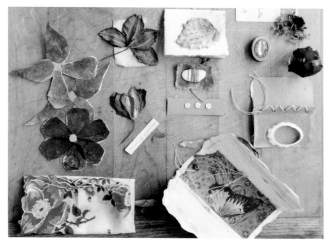

1 Gather and lay out your supplies

On your worktable, spread out pieces of papers, fabric, stitched projects, found objects and treasures from nature. Find colors you are attracted to that could fit well in the creation of a new collage. Let your thoughts take you to a place where these colors can come alive in your work. The butterfly collage on the top right corner is called "Fly Away Home." The butterfly collage on the bottom right folds into a book and ties together with old silk.

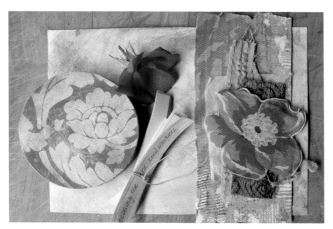

2 Prepare background and select elements

Prep a piece of watercolor paper by glazing it with thin layers of acrylic paints and matte medium. Find papers and fabrics that are different textures and decide which ones you want to use in this collage. I even cut out one of the flowers from the corner of the vintage hanky that you saw in the last photograph and planned to use it as my focal point.

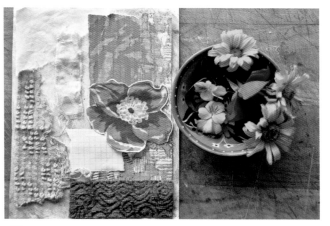

3 Decide on your composition

Play with design by moving your collage materials around until you have a composition that appeals to you. Carefully pile your papers and fabrics to the side of your paper. Begin adhering each piece using matte medium (review my tips in chapter one). Start with the background pieces first. You might need a glue stick or craft glue for heavier fabrics. You might also decide that you want to let the surface of the fabrics stay natural without any adhesive.

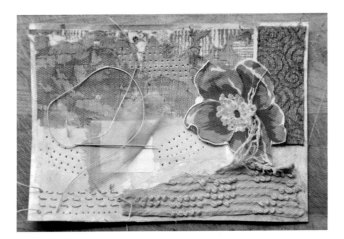

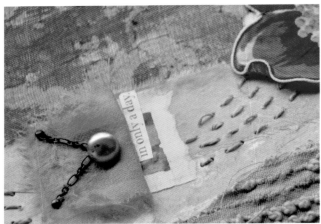

4 Prepare holes for stitching

When all your pieces have dried in place, carefully poke holes in your collage where you want to add stitching. Here you can see that I left some of my edges loose and didn't adhere them down completely. While you sew, keep in mind where each row will begin and end so the stitching stays in one direction on the front.

5 Add focal elements

After you complete your hand-stitching, search for focal points. I used the words *in only a day* and a vintage piece of chain and an old pearl button. I used tiny brads to attach the chain and the little yellow piece of fabric. It took me a few days to decide what to use here. I believe that the right pieces for a collage will surface if you are patient! Some of my collages take me weeks to finish, and others come together "in only a day."

Note to Self

Spend some time outside every day.
If it is hot, lie down on the grass under a tree.
If it is cold, bundle up and sit in the sunlight.
Listen to the wind.
Watch the clouds.
Feel the breeze.

I find that in my quest for a balanced life I have to spend time outside, especially in my gardens, for a part of each day. When I am alone in a natural setting, I feel more connected to the world and I am refreshed.

Where I sit out on the deck today, under the maple tree out front, I can look down on the Klamath River. I always marvel at the river's changing colors and the different birds that swim in it and swoop over it. As I write this I notice that my ornamental grasses are especially beautiful with their new golden tint. Across the river is long green grass also tinted with gold. The blue heron is just one of the beautiful water birds that we have here.

Out in back we have a patio that reminds me of a European courtyard. It has recycled red bricks and an old-fashioned, timeless feeling. I love to take still-life photographs there, using a glass table top as my surface. As I move my camera, I try to find the perfect angle where I can see the reflection of some of the sky or leaves on the trees above. Sometimes the objects that I photograph seem to be floating in a watery sky.

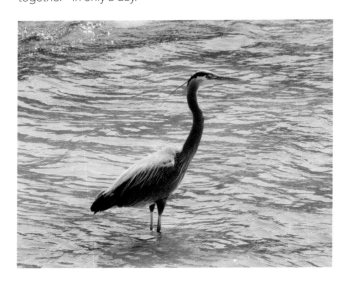

Stitching Adds Interest

Stitching to a collage can make it much more interesting. You can use stitching to:
• Frame an image
• Create a border
• Make a symbol or design
• Divide your paper
• Add details or texture
• Add color or contrast
• Create the feeling of movement
• Make patterns
• Attach objects

Important lessons:
Look carefully: record what you see.
Find a way to make beauty necessary;
Find a way to make necessity beautiful.
»»» Anne Michaels

I think that metaphorically we all have our own unique threads that weave through our art. A few years ago I asked many artists and friends this question: "What is the thread that weaves through your art?" The responses were all introspective and as individual as each artist. As the answers came pouring in my e-mail inbox, I was sometimes moved to tears by their honesty and beauty. I posted all of these responses on my blog, River Garden Studio. This question later inspired my wonderful workshop, The Thread That Weaves, which I have taught around the United States and online to artists all over the globe.

Task

Collage, draw or stamp a simple leaf shape on a piece of watercolor paper or canvas. Stitch the background, changing directions sometimes so it becomes a collage of stitching. If you like, you can draw lines first to follow. How has this page changed, just with the addition of lines of stitches? Did you pick colorful thread or more natural tones? Did you enjoy this process? Take photographs of your project with some flowers or plants from your garden.

A COLLAGE STORY
Sharmon Davidson

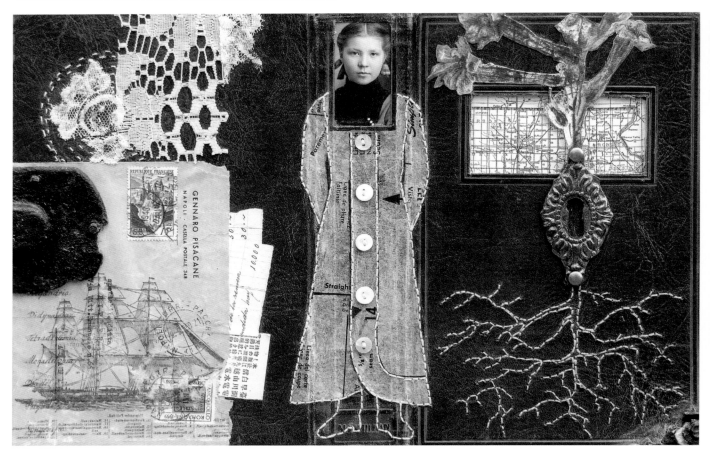

From a Far Country
9½" × 14" (24cm ×36cm)
Vintage letters/ephemera, vintage map, vintage dress pattern, vintage trunk latch,
vintage photo, vintage buttons, vintage keyhole escutcheon, lace, image transfer of
image from vintage dictionary, monotype, brads, stitching on a vintage book cover

One day my husband and I were walking through a field
near our land, out in the country, when we came upon some
gravestones under a huge old tree. Many had fallen over or
broken, but we were able to gather, by examining the rough
and eroded pieces of limestone, that they belonged to a fam-
ily named Kilgallen.

Some of them had been born in Ireland during the mid-
1800s. Now the land was not owned by anyone by that name,
and as far as we knew, there was no one by that name in the
area. It was a mystery. What was their story? I couldn't help
wondering about them. What had made them leave the land
they knew to emigrate to an unknown place an ocean away?

It appeared that some of them had been children when
they came here; others had been born here and died in
infancy or childhood. Had the family given up and moved on
to another place? Perhaps they moved west, as many were
doing during those years.

They captured my imagination, and I wondered how
one would find the courage to leave behind your whole life,
get on a ship and leap into an unknown future. I imagined a
young girl, scared and uncertain, trying to put down roots in
this wild and unsettled country. It was this imaginary girl who
inspired this piece.

Sharmon has a way of combining the ingredients of her collages in a fascinating way. Her love of history and nature is apparent in all of her work. Her stitching weaves through her collages like a song. You can view Sharmon's blog at sharmond.blogspot.com.

Windows on My World

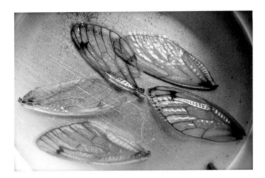

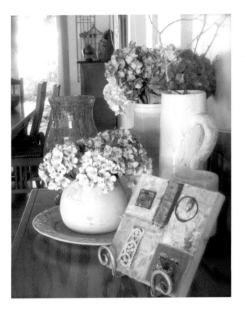

If you look into my world today, you would see my collections of glistening insect wings and rusted wires and old watch parts, of old textured bowls filled with African violets and silk hydrangeas in old crocks. And you would see how the light comes in through my windows, casting ever-changing light and shadows on the things that I love, as if to say, "Take notice, this is your home."

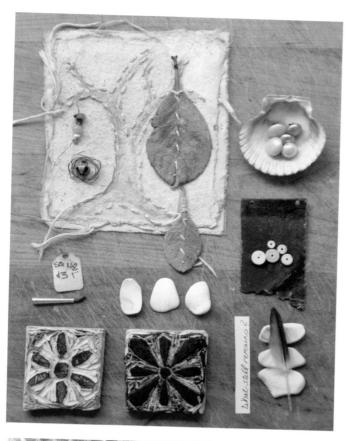

Note to Self

What still remains on your worktable after you finish a project? This is the question I asked myself after I finished my collage for this chapter's challenge and before I cleaned up my worktable. I often look over my collages and photographs of my still lifes and think about what the connections are, and now I wanted to rearrange these pieces in a temporary collage. Here seemingly unrelated objects have become related, beginning with the top left corner. I love to stitch over tree shapes. Over the heavier thread I sewed in and out with lighter weight golden thread and attached some beads. I stitched the leaves that are hanging down over the tree when I was traveling home from a California workshop with a friend. Buttons, shell fragments, beads and a feather draw your eyes around to a broken paintbrush, perhaps a symbol of creativity I often use in my collages. On the bottom left you can see two of my hand-carved stamps that I like to use on journal pages and the handwritten question, *What still remains?*

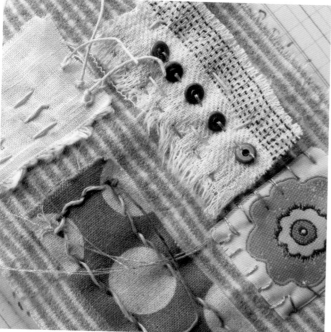

Task

Pick a small handful of different fabrics or papers from your stash and arrange them in different ways on a piece of watercolor paper or fabric. When you find a design that you like, adhere the pieces lightly or pin them down to hold them in place. Stitch around them, poking the holes first if you use paper. Remember that a fabric background like the one I used here is much more flexible.

I have found that if you love life, life will love you back.
»»» **Arthur Rubinstein**

A COLLAGE STORY
Annie Coe

·····································

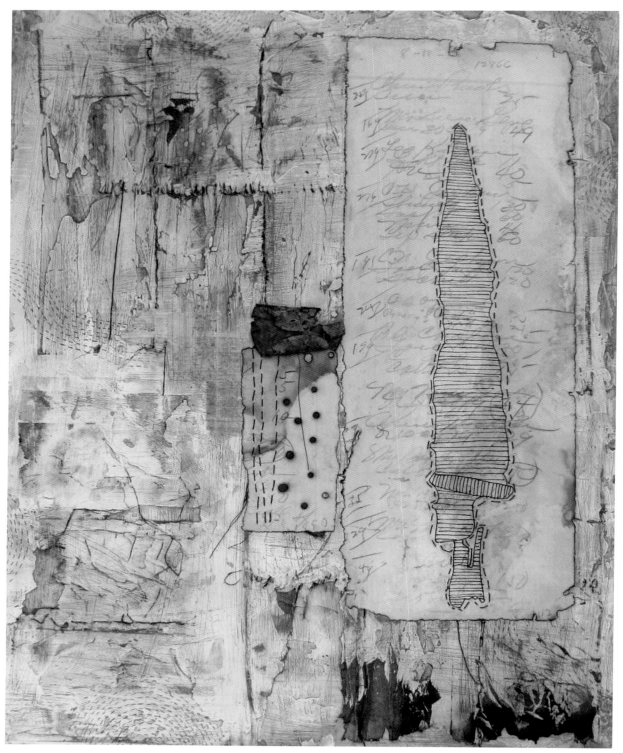

Future Archaeology
20" × 16" (51cm × 41cm)
Paint, graphite, rusted tea bags, 1945 ledger papers, tea and rust, thread,
rusted metal, art paper

I find collage to have a magical alchemy, and I know I am not alone in this feeling. It always starts out as a grand adventure. Sometimes the collage comes fast and easy, but that is rare. Most of the time the adventure turns into conflict and doubt and with this piece, fear.

I have never done a collage for a book, so I felt some self-imposed pressure. After weeks of pulling bits together and doing the background, I taped the elements on the board and there it sat for a week. I changed the bits and it sat for another week. Finally I had what I wanted but found I had a lot of fear of attaching the elements to the board.

What was this fear? One evening I woke up in the middle of the night and it came to me: I was afraid to commit. I realized that I was being too precious about the collage, and in the morning I got to work attaching all the ephemeral bits and my fear vanished.

I finished the piece that day and it went from fear and conflict and doubt to a happy magic. I love that about collage and it is why I do what I do. I have found that for me there is no greater joy.

Annie uses stitching in her collages as intricate details to accent her subject matter, which usually is a depiction of the natural world. To me, they look like pathways. View Annie's website at anniecoesstudio.weebly.com.

Jane LaFazio

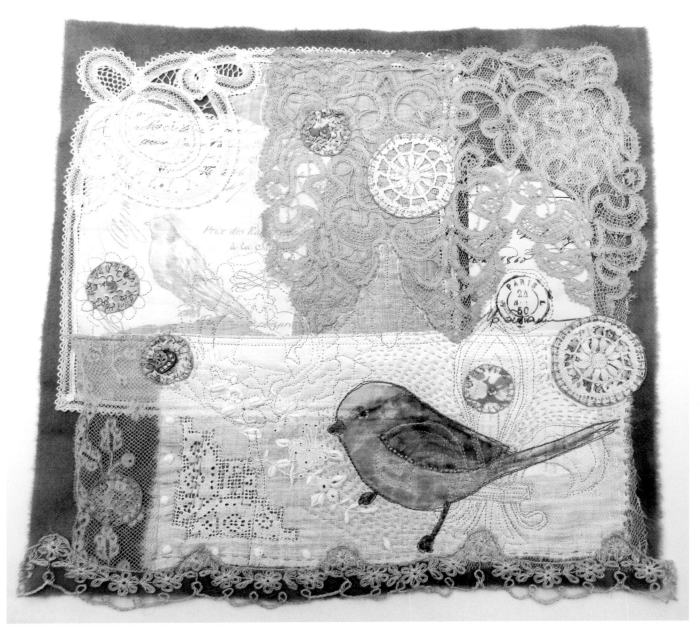

French Flight
13" × 13" (33cm × 33cm)
Vintage linens (napkins, pillowcases etc.), vintage lace, wrapping paper, sewing machine thread,
embroidery thread, image to free-motion stitch, image transferred to vintage napkin, small amount
of commercial fabric on wool felt backing

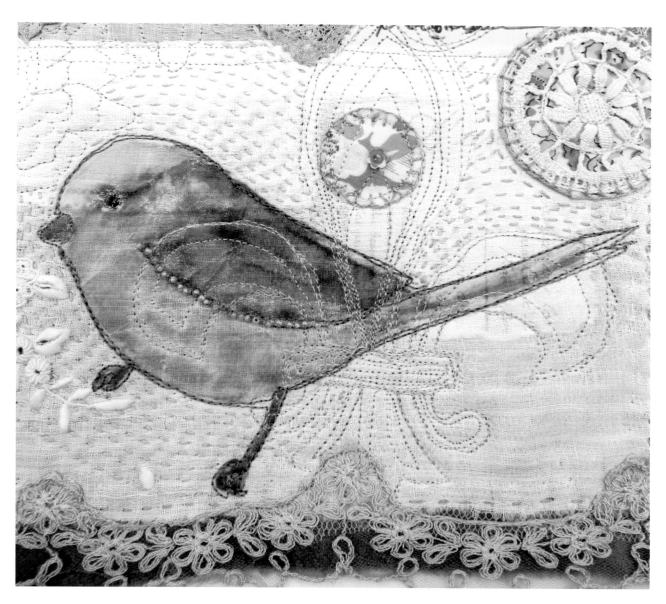

When I travel to the south of France, one of my favorite activities is to sketch and watercolor at the outdoor markets. And while I'm there, I might as well shop! I love the French flea markets! On my last trip, I shopped for small bits of antique lace, handwork and linens, and found many of the pieces for this small art quilt, *French Flight*. I composed this piece using the vintage cloth and lace purchased on my trip to France. I added an image transfer of a bird that I'd painted in watercolor and layered antique-looking paper with a Parisian postmark and a drawing of a bird. Lastly, I used my sewing machine to free-motion stitch a peony (I saw lots of those in the markets in France!) and the fleur-de-lis.

I love to create a work of art based on travel. It helps me reflect and relive parts of my adventures abroad.

Jane is a lovely artist in both her drawings and paintings, but also in the way she adds fabrics to her collages. You can visit Jane's blog at janeville.blogspot.com.

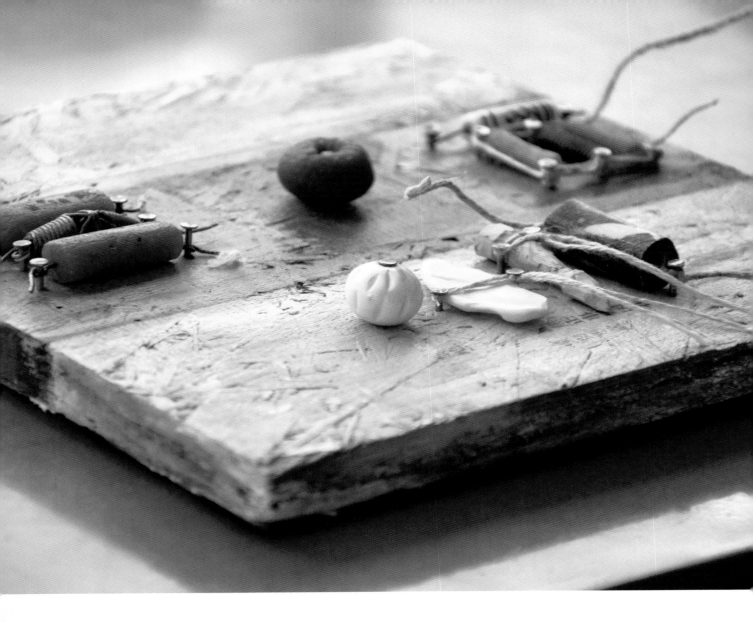

SACRED SPACES

My husband loves to build things, and that means there is always discarded wood around the garage. The particle board that is the base of this piece was one of several scraps and I loved the square shape. I painted over it using heavy-bodied acrylic paints and collaged small bits of paper and text into the paint.

When I was finished painting, I thought that its grid-like design looked like a perfect background for me to attach found objects to. After it was all dry I played with moving some of these small objects around inside the different spaces. When I found the right "home" for the objects, I attached them to the board using small nails, string and wire. I made small groupings of shells, beads and wooden bits. One of the things I love most about this assemblage is that the string and wire have become an integral part of the design, just as important as the objects themselves. I named it *Sacred Spaces*, after this quote by Joseph Campbell: "Your sacred space is where you can find yourself over and over again." It reminds me to always look at the small details in an art piece as well as the piece as a whole.

CHAPTER 4
Collage *with* Found Objects

To us, art is an adventure into an unknown world, which can be explored only by those willing to take the risks.
»»» Mark Rothko

Since I was a little girl, I have collected bits and pieces from the outside, from the beach that we visit so often, from our travels or along the riverside or in mountains behind our home, but a few years ago this expanded to also collecting objects from the streets, old parking lots and rest stops when we were taking a car trip. These objects, a dangling piece of rusty wire, an old hinge or portion of a discarded tin can, are fascinating to me. I found myself wondering what their purpose was before they were abandoned or discarded. These found objects would find a home in my studio, and soon a small collection would be born.

The very act of discovery as you collect found objects is magical. You have found beauty in an unexpected place. You have collected a small part of history, and you are taking own-ership of being a part of this world. And using these objects in your art is a way of sharing your discoveries and inspiring others. When you experiment with using found objects in your collages, you are truly embracing the alchemist within.

Collections for me often start as gifts from friends or other artists and then grow as I find more to add to them. Here are just some of the things I collect now:

• pocket watch parts • square-headed nails • small round beach stones, ocean-washed shell fragments or river rocks, gray stones and white stones, stones with stripes, flat stones and round stones • twigs, different kinds and from differ-ent trees or bushes • old stamps, postcards and envelopes • vintage buttons, especially rounded pearl buttons with wires on the back • rusty washers • rusty stars • small tins and boxes • glass shards • leaves and flowers for pressing • little vintage notebooks and ledgers • rice papers and vintage silk • seedpods and sticks • vintage spools of thread • hinges, draw pulls and keyholes • hand-carved stamps

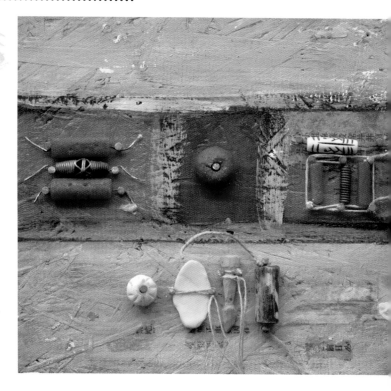

As you have probably noticed, I love to put my collections inside containers like tins or vintage muffin trays. Even small images become more special when they are placed in their new-found niches. Sometimes I just put a random group of objects together on a project board. As your eyes move around these photographs, what calls to you, what is mysterious and what is beautiful?

Today on My Worktable...

Creativity comes from looking for the unexpected and stepping outside your experience.
»»» Masaru Ibuka

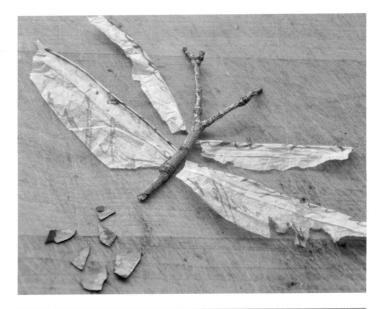

Whenever I start a new project I begin by clearing off my work areas and start fresh. The clean surfaces invite me to play, to work, to create. Often I first need to surround myself with things that inspire me before I even begin a project.

On this day I was thinking about how when given several objects, no two people would arrange them in the same way. I also wanted to celebrate being alive. I started with some of my favorite tins. Some are decorated on the outside only, and the blue one on the top right, *Emergence*, is altered on the inside as well. *In the Courtyard* holds little objects that I found out back and a little list of the objects rolled into a scroll and tied with old string. What I liked here was the different colors, the deep red, turquoise and blue, oranges and greens and yellow. On the top left you can see the insides of an art piece that I did for Seth Apter's first book, *The Pulse of Mixed Media*. It is called *Thus to Me*, and it contains many things that are important to me, however tattered.

As I moved these treasures around, I was very aware of the relationships between their colors, between wood and metal, the old and the new, and the written word. On a scrap of paper I had written the words "dance under the stars. Water your garden in the moonlight," that would soon become part of a longer list about celebrating yourself. When I photograph I like to play with lighting, moving objects around until the lighting is just right, just like collage.

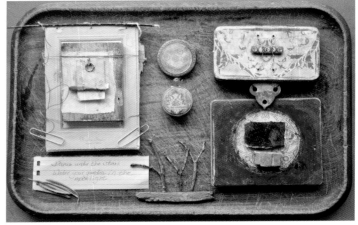

Note to Self

Give in to your impulses to play. That is what I did here: I gave in to the impulse just to play, making this paper and twig dragonfly and trailing chipped pieces of paint under him like stardust. Temporary art pieces are caught forever in a photograph.

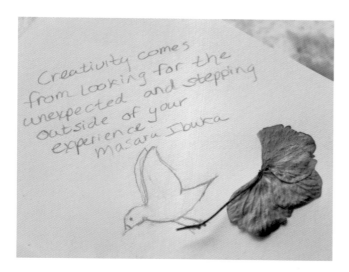

Creativity comes from looking for the unexpected and stepping outside of your experience
Masaru Ibuka

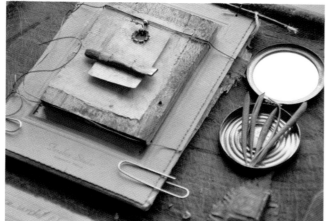

When I make a new book or book structure, found objects often become the focal point or a prominent feature. Whenever possible I like to attach my objects with wire instead of glue.

Note to Self

Celebrate your own uniqueness, the things that you love about your life, small treasures and moments that make your heart sing and make you come alive! What are things that you can do to celebrate yourself? Make a list of these things, no matter how small they are. On this day make sure that you do at least two of these things.

Here is my list:
Dance under the stars.
Lie on the grass under a tree and look at the sky.
Water your garden in the moonlight.
Smile at yourself in the mirror.
Put a vase of flowers outside on a tabletop or bench and take a photograph of it.
Remember yourself when you were most vulnerable. In your mind, give that person a hug.
Find a place inside or outside where you never sit. Sit down and look around to see your world from a different view.
Let your art, your collections, your written words reveal to yourself who you are.
Hug your pets, your husband, your family, your friends.
Sing.

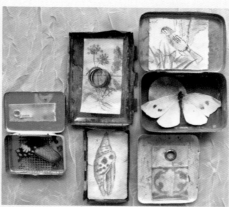

Task

Go outside and gather some small twigs. Sort them out by size or texture and find one that branches out evenly. Gather some torn paper and tear some wing shapes. Make your own dragonfly. Photograph it, write about it or even attach it into your art journal.

COLLAGE CHALLENGE
From This Land

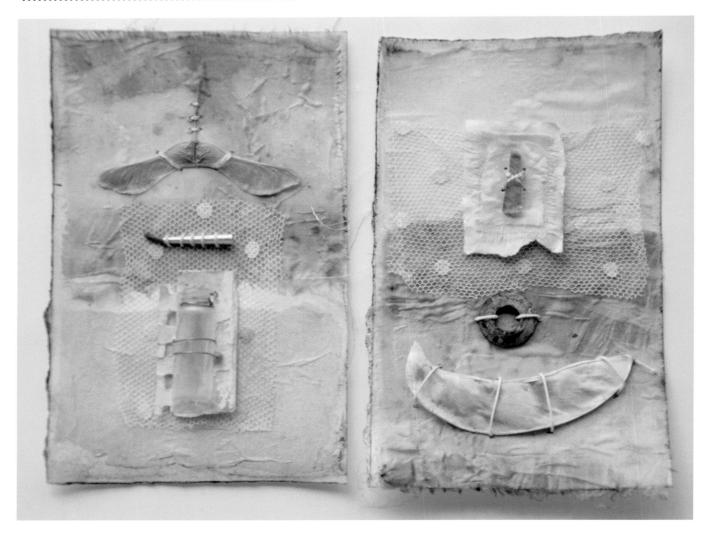

Many of my collages tell the story of the elements of the earth, the land, the water and the sky. These pages are meant to go side by side in the center of a book. The pale yellow represents the late summer sun, now more gentle as it moves lower in the sky. Born from fire and the inside of the earth, the metal washer represents the heat and what lies below the ground. Seedpods represent new life and nourishment; glass represents the water and the sky. The paintbrush represents creativity and the little bottle would be a perfect place for a word or a wish, small stones or even a dried flower.

As you begin this collage, think about the elements of the earth. In your mind, what colors and objects represent each element and what kind of background would complement them? How can you incorporate these elements into your collage? Creating this collage will connect you to the earth, the land, the water and the sky.

What You Need

- awl
- fabrics
- large-eye needle
- matte medium
- old paintbrush
- other small objects: beads, seedpods, pressed leaves, shells or flat stones, rusty washers, etc.
- paper towel
- papers
- pastel stick (optional)
- water dish
- watercolor paper, two pieces cut or torn to 4" × 7" (10cm × 18cm)
- wire or twine

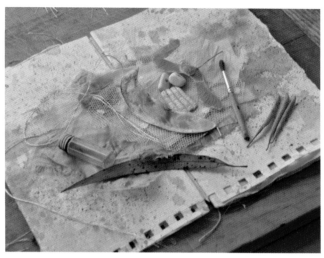

1 Gather your materials

I wanted to use the center pages of this premade hand-stitched book for my inspiration. I had painted the background with watercolors, spritzed it with a mixture of ⅔ rubbing alcohol and ⅓ water. I also flicked brown paint here and there to give a feeling of sand.

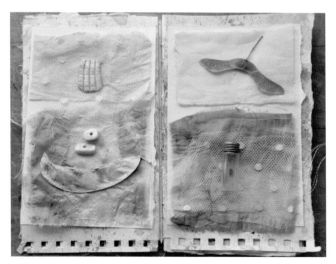

2 Plan your layout

Lay your papers, fabrics and found objects out in a way that's pleasing to your eye. Even if you change your mind later about placement (like I did), this still gives you an idea of how the composition works and what direction you want to go in.

3 Add background color with pastel

Think about if you want to stitch your objects right onto a journal or book page, or if you want to use separate pages and connect them later. Choosing separate pieces of paper to work on will keep all the ends of your wires and threads hidden.

If you are starting with fresh white papers, tint them using the sides of the pastel stick and then blend the surface with a crumpled-up paper towel. Spray lightly with hair spray to affix the pastel color on your paper.

4 Adhere fabrics and papers

Adhere your fabrics and papers with matte medium. For thinner papers use less and always blot off the excess so there are no puddles. Let your papers dry completely. (See my tips for using matte medium in chapter one.)

5 Secure some pieces first to paper

Play with design and placement again, thinking about how heavy or delicate each object is and if it needs a heavier surface behind it. Little bottles might need to be attached to another piece of paper and then glued onto the background later. A little shard of glass might look good framed with a layer of colored papers behind it.

6 Attach pieces with wire or twine

Start to adhere your pieces. With an awl first poke your holes, then start attaching your pieces with wire or twine, using a large-eye needle if necessary.

When your piece is finished think about what story it tells, what memories it brings to your mind. And what story might it tell to someone else?

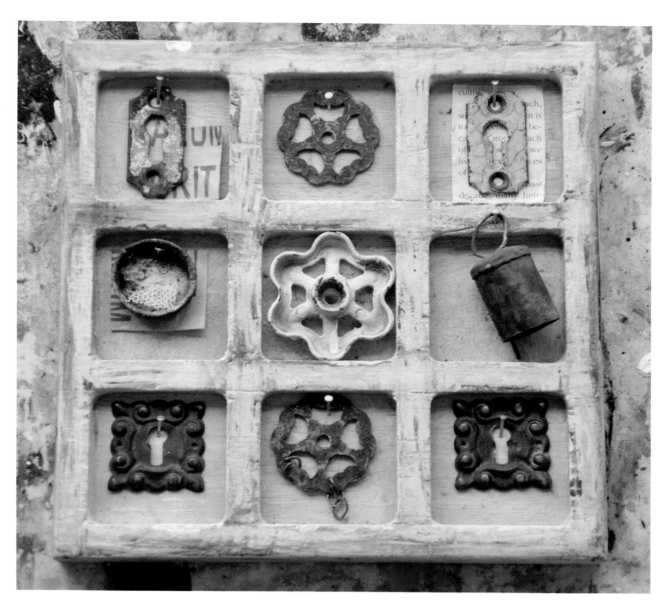

Note to Self

Create art from something repurposed. I found a tick-tack-toe board and carved out the spaces because I wanted to straighten out the curved corners. Then I sanded and stained it, and soon each space was home to an old piece of jewelry or a small door hinge. This assemblage/collage became a homage to the little town where we buried my father's ashes. There is an amazing antique store there, and an old flour mill. I found many of these items there, and now it reminds me of how I took care of him the last few years and what that did for me personally.

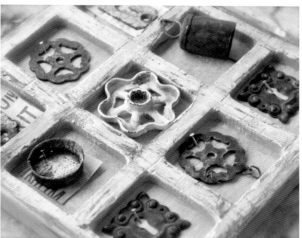

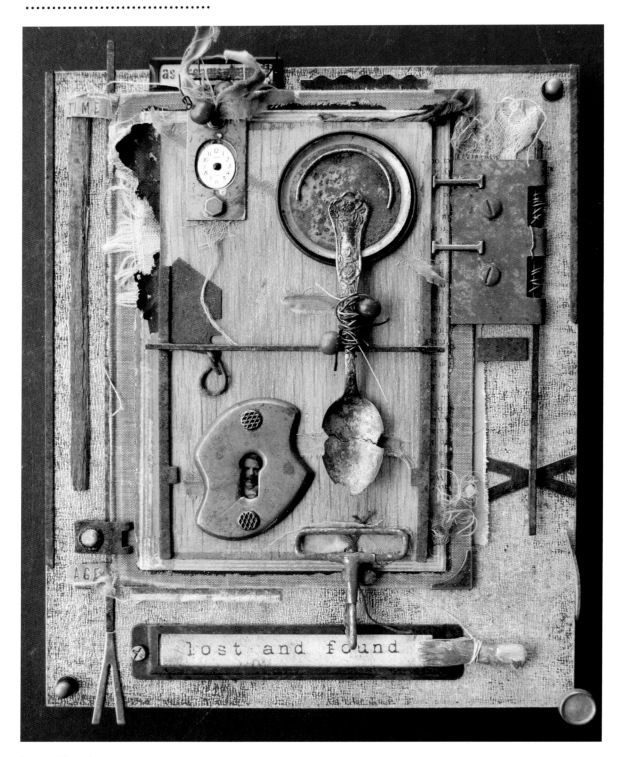

Lost and Found
10" × 8" (25cm × 20cm)
Gesso, acrylic paint, shellac, found objects, metal and wood embellishments, fabric scraps, beads, brads, wire, thread, paper, adhesive and vintage book covers, spoon, tintype, watch face, label holders, Santos hand, typewriter key and hardware on cradled wood panel

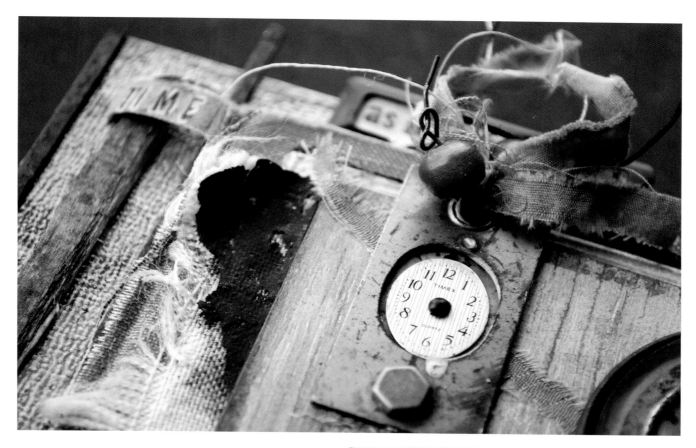

Lost and Found, like so much of my art, was inspired by a grouping of found objects. These to me are so much more than just art supplies. They are possibilities.

As I walk through the world, I am always on the lookout for the lost. I seek discarded objects with a history. Items that, whether on purpose or by accident, are no longer used for their initial purpose or by their original owners. Rusty metal, worn paper, bits of fabric. The detritus of life that seems to be well past its prime.

Not so for me. Every find is a true treasure that makes my heart beat just a bit faster. Each object comes with its own history that will now continue rather than end. All the pieces await their turn, at the ready for the time when they are needed to complete an artwork. Sometimes that is immediate but most times, the wait is long. The objects don't seem to mind.

Seth's collages and assemblages have a definite story to them, and his work is multilayered with textures and colors. See Seth's blog here: thealteredpage.blogspot.com.

Windows on My World

Today it is late afternoon and I am sitting outside in one of the few sunny spots left on our front deck. The sun is low in the sky in the back of the house, already behind the old pine trees on the other side of our property. My two dogs and cat are all close enough for me to pet them, and the wind chimes are humming and clinking ever so softly. In this spot I feel that I could reach up between the maple leaves and touch the sky.

I just came home from teaching an amazing two-day workshop at Art Is You in Petaluma, and not only am I inspired but I am happy, for while I was gone, heavy rains soaked the river lands and the forests, and even more lovely to me, our

gardens. Our long, hot summer is now officially over, and the threat of wildfires for this year has passed.

So I am grateful and content in the yellow light of autumn with its warmth on my skin.

I love this time to write and watch the world before me. Our house sits on a hill, and our view of the river is lovely though not as expansive as it was when we first moved here.

When we first moved here and before my son was born, I used to walk over the fields below with my daughter, Amanda, when she was little and our golden retriever, Shasta. She was named after Mount Shasta, which rises high in the

Only from your heart can you touch the sky.
⟫⟫ Rumi

sky to the south of us and is always exquisite. The three of us would often stop to sit quietly on a rock pile and listen to the meadowlarks and watch for lizards or turtles.

I would imagine times long ago when Native Americans roamed by this river, hunting and gathering. I thought that maybe another young mother like me would watch the sky and the ground, looking for beauty in expected places.

I am constantly excited by the chances to learn new things and share them with others. And it is important to me to find new ways to see the world. Now as I take a walk around the house, first under the old ash tree, then around the birch and aspen, then through the shaded garden under the willow and maples, I collect a yellow daisy and a pink cosmos, a shard from an old pot and a tin box lid. There is always something new outside to catch my attention, and on this day these are my finds. I put some rose petals and a few carnations in a bowl of water that the birds bathe in, just to see how the colors look next to each other.

In the late summer our house is a shaded sanctuary filled with secret gardens and surprises. Outside I can sit or garden and be completely unseen by the rest of the world. I photograph the vintage loveseat, which used to be my mother's, with its fresh coat of marigold paint. And when I get back into the house, the tall pink hollyhocks dance and sway outside the window.

A COLLAGE STORY
Rebecca Brooks

The Alchemy of Becoming
24¾" × 16¾" (63cm × 43cm)
Metal crown with stars, vintage Mexican iron furniture embellishment, details with white acrylic paint, antique glass, Mexican vintage image of Mary (circa 1850–1900), mouth-blown glass rondel, paper, clay, dried bougainvillea, flowers, old brass channel, metal leaves, Grammie's vintage earring, German gold foil, small glass circle bevel, metal cast coronas, handmade silver heart with cross, small round beveled mirror, dove milagro, metal filigree, small glass flower, vintage white bead flowers with rhinestone earring on vintage wooden mirror frame

When does it happen? That moment when things that have whispered to you quietly over the years set your heart in motion and the alchemy of becoming gives birth to deeper meaning? This story begins with a wooden framed mirror stationed on the dresser of an ordinary life. Its purpose, to reflect honestly the passing chapters of time. Once the mirror was broken, it was cast away to end its life in a modest thrift store, empty, waiting.

Rebecca's art tells stories of Mexico: celebrations and festivals and traditions. Her art is filled with light and ever-present reverence for the gifts of nature. See Rebecca's blog at corazon.typepad.com.

A COLLAGE STORY
Robyn Gordon

Spirit House
24" × 16" × 1½" (61cm × 41cm × 4cm)
Fragments of my early carved totems, obeche wood (which comes from the Congo), found objects, nails

This piece was inspired by Sepik spirit houses in Papua New Guinea, as well as the house of the *hogan* in Mali. A *hogan* is a Dogon spiritual leader whose house serves as a conduit for spirits to drift through while communicating with him. I was amused by the idea of a mobile spirit house that could fly or sail . . . or drive over a bumpy road in Africa. I have used fragments of my early totems, which I had previously banished to the back of a dark cupboard. There were parts of the old totems that I loved, so I sawed these off to use in the assemblage. I've also used found objects that I've collected over the years, my favorite being the rusty egg-shaped offering bowl on the lower right of the piece.

Robyn works primarily in wood. From her home in Africa, she carves and attaches found objects that have a special meaning to her. I love to read the stories behind her work almost as much as I love her pieces. Please visit Robyn's blog at artpropelled.blogspot.com.

page is in the air

there is magic

A CHANGE IN THE AIR

The day I made this collage was late in November after an especially lovely Thanksgiving. Outside there was just a little color left, and what color there was had fallen from the trees and sparkled on the wet roads and the still-green grass from summer. It was quiet after all our family had left our house except my husband and me. They were on their own journeys home, and I was feeling a mixture of both happiness and wistfulness.

As usual, gazing out the picture window in my studio gave me comfort, and I was filled with gratitude for my family and my home. On my worktable, I laid out some images that reflected the color of this month—these days before winter of stormy skies, wind and rain, and mostly of sweet family moments.

These photographs held a special memory to me. The berry was from a hike in the Santa Monica Mountains. When I was a senior in high school, I got my first "real" camera and was learning how to take close-ups of nature, something I still love to do. The wintery scene is just how our front gardens look right now with the river in the background. The shimmery yellow fabric is a photo I took of a dear friend's scarf after a day outside in her gardens, and the white flower image I had torn from an old garden magazine. Now I have flowers like this in my own garden.

Before I began this journal spread, I reinforced the joint in my small Moleskine with a piece of muslin, glued two pages together on both sides, and painted a layer of gesso on the front surface, all to make the facing pages strong.

I found a torn piece of rice paper with marks that seemed to just fit, mysterious symbols from another land. I also used papers and fabrics behind the collage, a piece of antique lace and one of my own stamped images on silk. I decided not to use the red berry photograph after all.

CHAPTER 5

Collage *with* Photos *and* Images

November is a bittersweet month for me. During November I had two different miscarriages from two different times—that don't feel too long ago—and that longing and emptiness I felt then still surfaces during this otherwise beautiful month. At the same time my heart is filled with warmth for my family and my children. I always find that this is the season of reflection, of dark and light, of retracing my pathways and discovering new ones.

A Change in the Air reminds me of the moments that have made up my life.

Are you drawn to photographs that depict a certain scene or evoke a certain mood? Maybe those with a color scheme that you love or the feeling of another time? Like many of you I've been collecting images from magazines for ages just because they move me in some way. Sometimes I use them right away in my collages, and sometimes I don't use them for months or even years. I cut or tear them or cover them partially with gesso, and I often like to sand them down slightly, but the feeling is still there

When I think of my collages, I feel how they are connected to each other. They often tell the story of contrasts: that which is old or new, made by nature or made by hand. Images of symbols and stone, insects and leaves, and the elements of the earth are often an important part of my collages.

Task

Do you have a stash of photographs that you have kept, just waiting for the time to do something with them that will bring them to life? Collect a group of them that appeal to you at this moment.

In an art journal, practice arranging them across two pages. What story do they tell? What do they make you remember? A special time, a sad time, a time you are grateful for? Write down this story and why, at this moment, you picked these images.

Today *on* My Worktable...

*What we choose changes us. Who we love transforms us.
How we create reshapes us. What we do remakes us.*
»»» Dr. Eugene S. Callender

Late this afternoon my worktable is filled to the brim with
ideas for future collages. Very similar to my piles of colored
papers that I love to bundle up are my piles of images that
might work together in a collage. They are together because
of their colors, their theme or even because of their contrasts
in color or feeling. The side of a rusted tin barrel, an autumn
leaf, a Buddha, a yellow leaf with a turquoise bead on it. Blues
and reds, shades of black and white, reflections, a cat sitting
in a doorway of a shop in a small Oregon town. Metal and
stone, paper and glass, fabric and paper. A magnifying glass
that I had given my father. All brought together in this creative
process of mine.

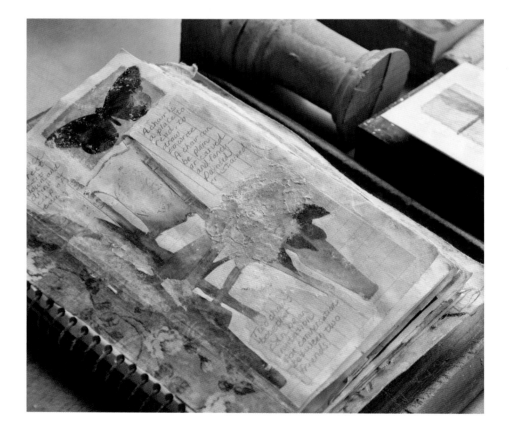

These pages are from one
of my first art journals and still
give me comfort because of
what the images represent
to me. From the beginning
I have loved vintage writing,
graph paper and using lots
of layers. This art journal
was a sketchbook, so the
pages weren't as sturdy as art
journals made of watercolor
paper, which I typically love to
work in now.

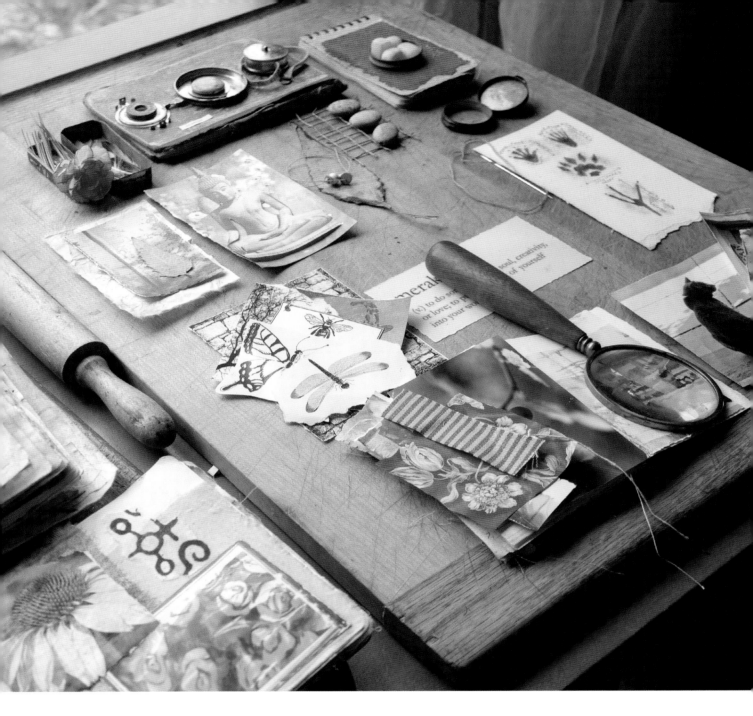

Up at the top of my worktable you can see a small temporary assemblage that I named *Moonstruck*. Although I primarily use warm colors in my collages and paintings, I find myself drawn more and more to grays, silvers and blues. I took this little slip of a word and made this little grouping on the cover of a vintage child's reader. As I worked, I was watching the moon rise over the river. I used to tell my children when they were little and we were driving after dark that the moon was following them home. This notion is so sweet to children, and I know that many other parents say the same thing to comfort their children and make them feel safe.

COLLAGE CHALLENGE
The Cornerstone

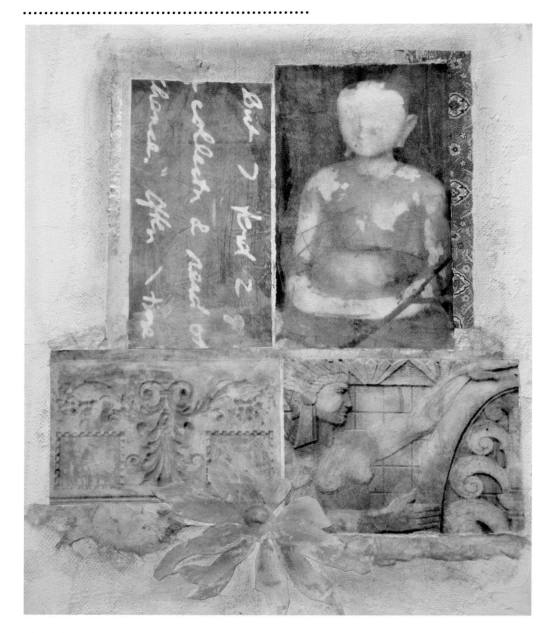

This collage began with a field trip to Cornerstone in Sonoma County, California, which I took my workshop attendees to during the autumn of 2014. Not only was this a delightful group of artists who also loved taking photographs, many of them had "the eye" for finding amazing settings and compositions, and we all happily learned from each other.

The Cornerstone is made up of my own photographs of this magical place, filled to the brim with art and artifacts, natural garden spaces and man-made structures from the past and the present.

For your collage, think about journeys you have taken, even in your imagination or your sleep. Can you create a collage that tells the story of one of these journeys? What kinds of art do you love? What makes your heart sing? I believe that when you think about these things, and especially if you write all of this down, you are developing and affirming your own style, and your story is being told.

I printed my images using a laser printer and lighter weight matte photo paper.

I sprayed my images lightly with hair spray to preserve the colors, but you don't have to do this. Images that bleed are also very lovely in a collage, and even spraying it with hair spray will not prevent it from fading just a little.

What You Need

assorted fabrics and papers

brayer

canvas, 9" × 12" (23cm × 30cm), wraparound

hair spray (optional)

images, magazine or original photographs

matte medium

old paintbrush

palette knife (optional)

paper towels

parchment or wax paper

water dish

white gesso

1 Prepare your canvas and gather images

My canvas had a yellow tint and I wanted to preserve a bit of the yellow. If you like, you can first tint your canvas with a slight bit of watered-down color. Using a paintbrush or a palette knife, prepare the canvas by loosely covering all sides with a layer of white gesso. An uneven layer of color and gesso will add interest and depth.

Gather photographs and images that have something in common or are connected somehow or evoke a certain feeling.

Pick some background colored papers or fabrics that you might want to use and lay them out on your project board or worktable with your tools. Leave your collections out for a few hours or even a day, adding and deleting as the hours pass until you have a collection that looks right to you.

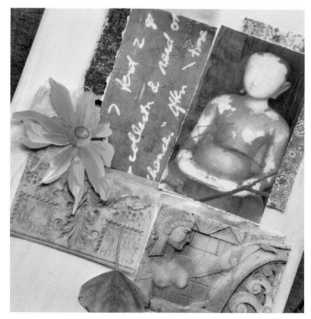

2 Play with the images

Cut or tear your pictures into desired shapes. Make them different sizes and experiment with cutting some images out completely like I did with the flower and the leaf. Practice arranging your images over different colored papers or fabrics.

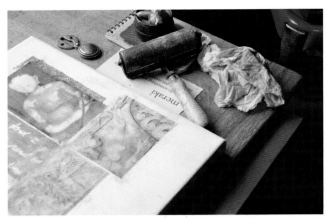

3 Adhere your images

When you find a design you like, move everything over to the side and begin adhering them to your canvas with matte medium, first the backgrounds and then the photographs. Review the process I included in chapter one.

Because my photo paper was nonporous, I found more air bubbles occurred. If that happens to you, lift up one corner at a time and slowly press out the air bubbles with your fingers.

4 Roll over adhered images

Blot your collage gently with a paper towel. Put a piece of parchment or wax paper over it and gently roll it with a brayer. Your collage might be finished at this time, or you might decide you want to add some words, color or marks. If you used a wraparound canvas, you may want to turn it upside down on a piece of parchment or wax paper and then roll it with the brayer.

Notice the way my collage pieces are not exactly centered on my canvas, either vertically or horizontally, and the background papers are only partially visible, giving a hint of color or texture.

As a final step in finishing *The Cornerstone*, I scraped another layer of gesso around the edges again with my putty knife. I also partially covered the yellow flower with gesso so it wouldn't be so prominent.

When you are finished with your collage, what story is revealed? Write it down in your art journal. If your collage doesn't seem to want to tell a real story, make up one from your imagination!

Once you make a decision, the universe conspires to make it happen. »» **Ralph Waldo Emerson**

5 Add final details

Let this part of your collage dry completely while you think about what details you might want to add. You may change your mind at this point as I did about the placement of the flower and decided not to use the leaf.

Possible things to add might be other smaller images, a pressed flower or leaf, a stamped image, stitching or text.

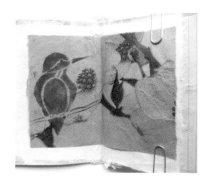
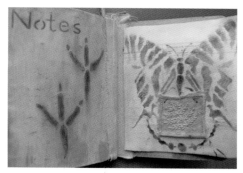
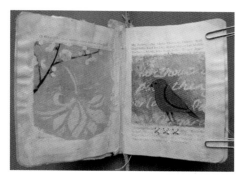

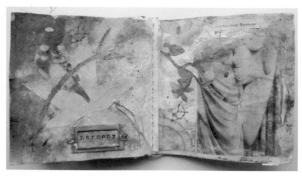

These are some of my collages using images, all in art journals or altered and handmade books. Some are with my own drawings and stencils; others tell the story of a passing day. Creating art is my way of finding harmony in my life. The hummingbird is one of my own stencil designs, and I painted it over some old paper from a World Market bag. The little red bird, the white flower, the butterfly and the bird tracks are also from my own stencils. I made a little book with them to show how you can use stencils on different types of backgrounds. The woman with the white cape was drawn on another art journal page with the addition of an oak leaf from the Oregon coast. To me it seemed to fit perfectly on the page.

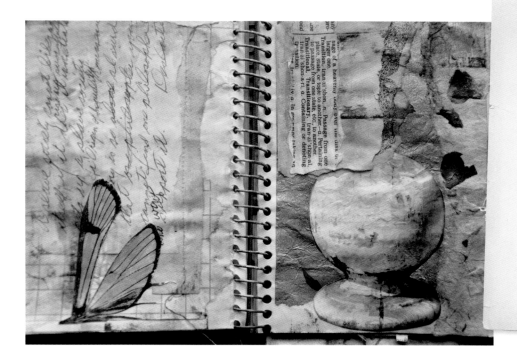

Task

In the collage with the butterfly I added some of my father's handwritten notes. He used to scribble this sloppy but expressive writing in notepads when he listened to classical music. Do you have an old letter from your mother or father or someone you have loved that you would like to preserve on the pages of an art journal? Even a grocery list or a recipe would work! Try to build a collage around this. This is a wonderful way to include your own personal history in your artwork.

Orly Avineri

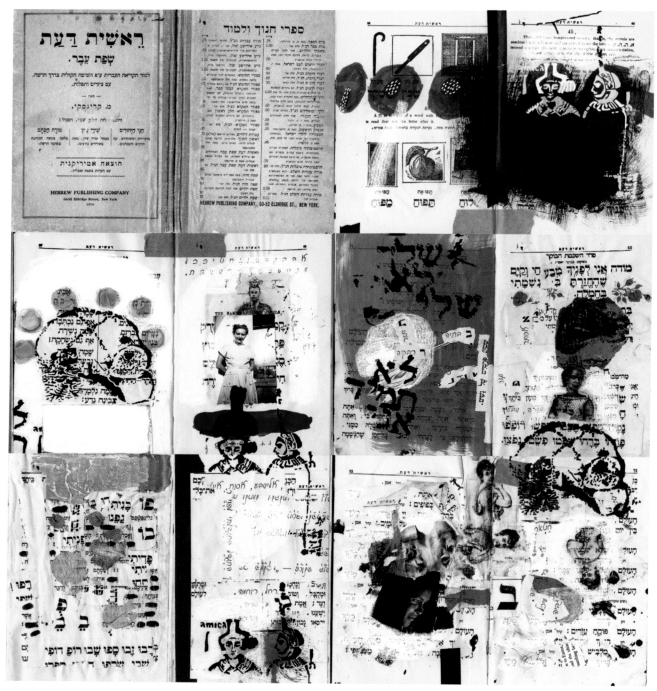

In Front of You
19½" × 17" (50cm × 43cm)
Old book, clip art of women printed on tracing paper, magazine clippings, old gift paper,
clippings from the same book, acrylic paint, black gesso, white gesso, colored masking
tapes, dried flower petals, tear-outs from previously made art, my own stencil designs

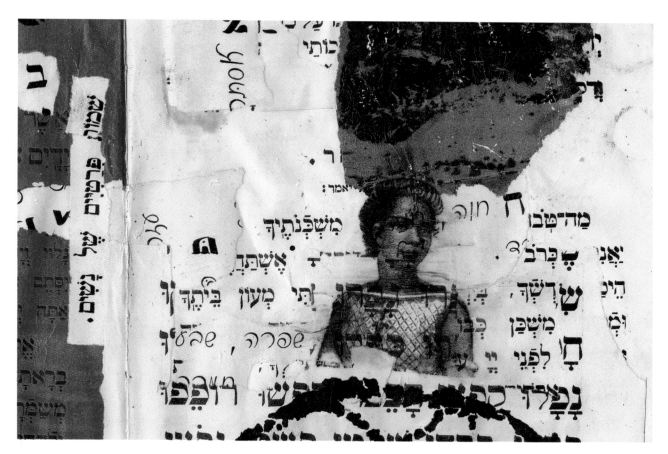

This is a Hebrew learning book that my curious and kind friend Elise gifted me. She said she found it at a thrift store for fifty cents. She also said she loved it at once and knew it was destined to be mine. It was published almost a hundred years ago, in 1918, which made it feel sacred and me rebellious. At that time Hebrew was taught through the ancient biblical language, not through the modern Hebrew we speak today. It offered me the visual and emotional stimulation I would need to create any type of art, especially one that is inclusive of various materials like a collage. It immediately piqued my curiosity, so I needed to hold it, touch the pages and sense its nature. Although I knew little of what would become of it, I knew that it was of great interest to me.

It was of interest to me for how easily it fell apart at the seams, how aged and delicate the pages in it were, and how the Hebrew letters, words and texts pulled me in and ejected me all at the same time. It reminded me of how familiar I am with the content in it and also of my estrangement from it. All at once history and story, both intimate and shared, intertwined and caused me unrest. Once again my ambiguous worlds collided and came into conflict with one another. Soon thereafter the whole book became a collage, a physical place, another opportunity for me to sort things out and bring forth some new truths about where I am coming from. Through the process of collaging I fooled myself in believing that I am in charge of my story.

And so I was altering the textual and visual realities of this book, building upon what was already there and then layering images, photographs and clippings from previously made art. I've been cutting, tearing and pasting foreign elements and juxtaposing words that I removed from one page with existing words on another. I was changing the original content to accommodate newness of thought and belief, one that would hold new meanings for me. Through this collaged book I am sharing with you that I want to go home although I can't tell you where it can be found. Fragments of words and images conjure up memories, some stagnant and never-changing, and some fluid and ever-changing.

Orly's art journal pages are filled with intricate emotion and passion. You can see more on her blog at oneartistjournal.com.

Windows on My World

During this beautiful season in southern Oregon there is magic everywhere. These photographs not only portray the colors of late autumn in my gardens but along our river lands and in the mountains behind our home.

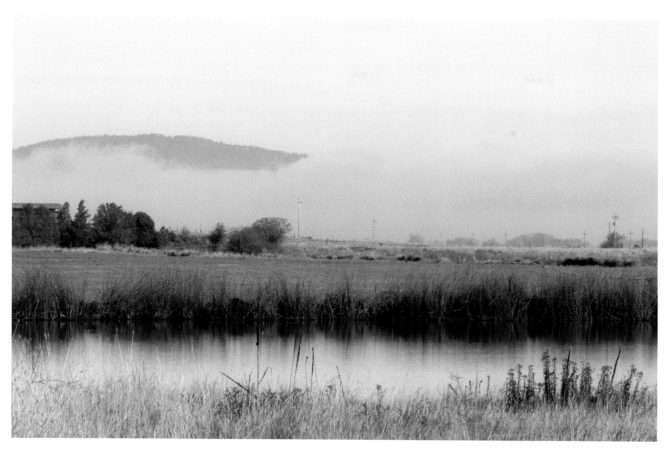

I look; morning to night I am never done with looking. Looking I mean not just standing around, but standing around as though with your arms open. »» **Mary Oliver**

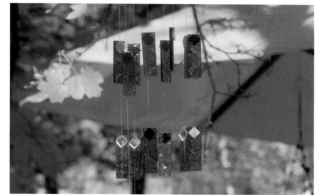

Task

Find several photographs or images of different sizes that you have saved because you were drawn to them and arrange them on a piece of heavy watercolor paper or on a page in your art journal. First, without adhering them, arrange them from the center out, then arrange them around the page, leaving the center empty. Are the designs different? Which design appeals to you the most? I use both of these approaches in my collages.

Sarah Fishburn

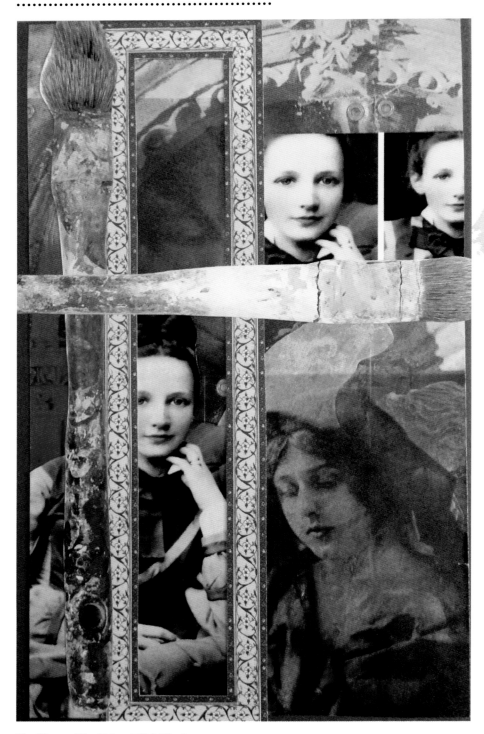

The woman was one who painted with words—a poet, though seldom acknowledged as such.

Most saw what she crafted, examined it closely, and called her a Visual Artist; they failed to listen when she objected; they said, "Look, this is a canvas, not paper, nor pen."

"It's not what you think," she insisted, but her protestations were ignored.

She tried again. "It's all in the rhythm, the cadence, the rhyme, and the tone."

When asked to discuss her work, she spun stories like fairy tales, filled with secrets and lies, concealed, revealed, and in fact, utterly believable.

»»» **Sarah Fishburn**

The Woman Who Painted With Words
5" × 8" (13cm × 20cm)
Anahata Katkin frame, Dr. Martin's Gold Iridescent Ink, grommets, torn magazine paper, PaperWhimsy image (repeating), vintage French postcards printed onto transparency, color copies, mat board, transparent tape

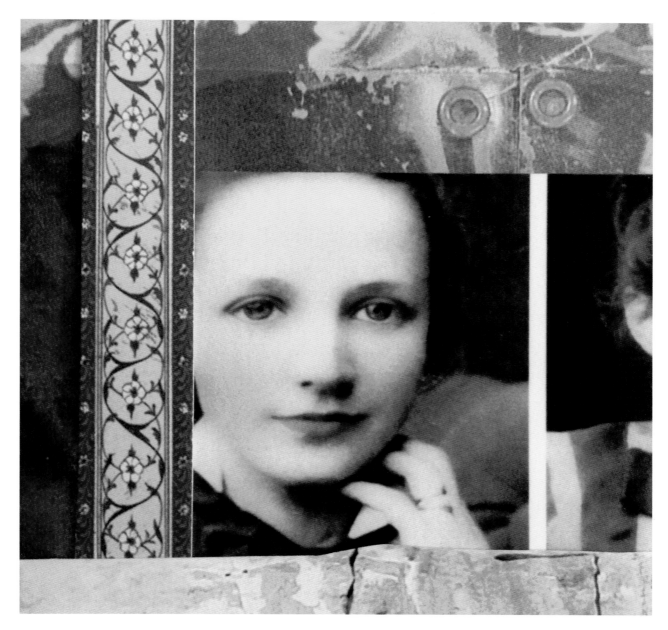

When pinned down, I have occasionally referred to myself as a "narrative artist." I think when people see that label and observe the consistent use of words in my art, they often think *Oh, that's what she means!* It actually has nothing to do with the physical presence of words in most of my collages.

As a narrative artist, I am driven to tell stories with my art. Story has been the driving force of my life since I could first understand the spoken word. Long before I could read, I listened to stories, rarely 100 percent factual—because story lends itself to interpretation, to embellishment—told by my grandparents and their friends, told by my aunts and uncles, by my mother … Now I tell stories as well: mine, theirs, ours.

Sarah uses many of her own photographs in her collages and they often have a romantic passage-of-time feel to them. See Sarah's website at sarahfishburn.com.

Joanna Pierotti

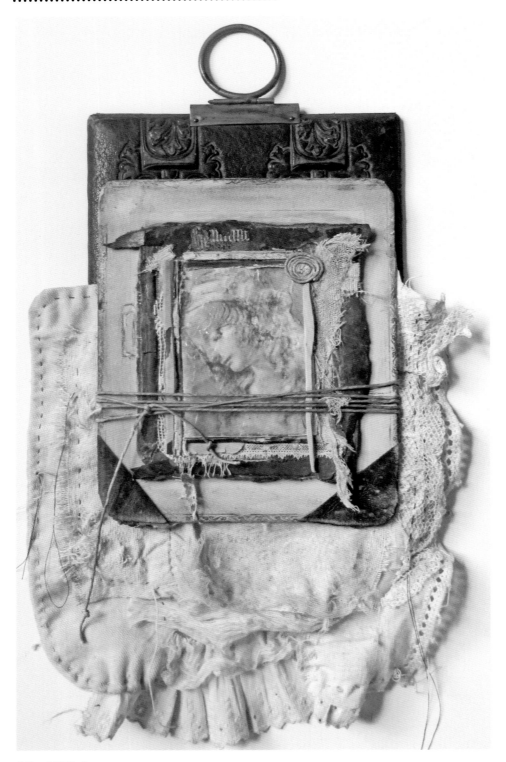

I Can Still Feel
12" × 8" (30cm × 20cm)
Leonardo da Vinci image, antique leather photo album cover, cabinet card,
book cover remnants, mica, chalk paint, waxed twine, wood stick, leather,
vintage fibers

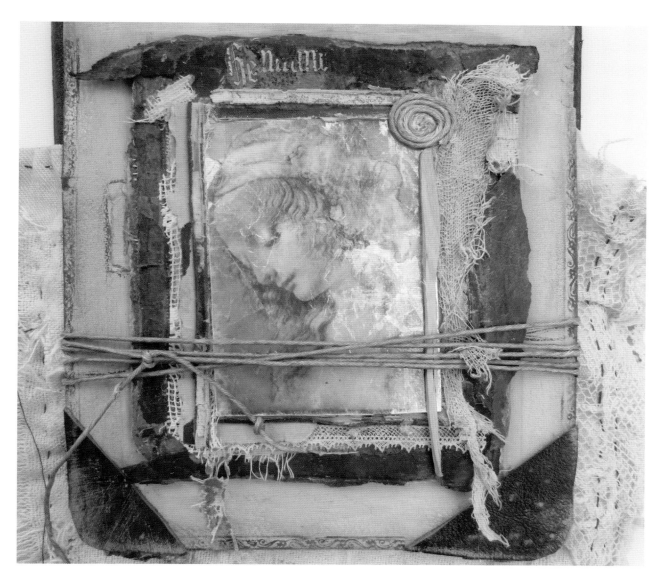

While assembling this piece, it was at the time of my mother's birthday, which would have been her eighty-third. It has been almost seven years since she suddenly passed without saying good-bye. The raw emotions have healed of such heartbreak, yet sometimes I can still feel how I felt that very day receiving such shocking news. A void in my heart will always remain that no one will ever be able to fill.

I catch myself from time to time smiling or even laughing, reflecting on some of my "mom times." She was full of life. She could be silly. She loved to laugh. My mom was an artist, a lover of fibers and pretty lace. In her younger days she was a collector of antiques. I still remember her digging old bottles from the ground in our home state of Connecticut.

One of my favorite moments with my mom was when we were living up in the Sierra Nevada foothills and she came for a visit. It was a moonless night as she looked up and saw the Milky Way for the very first time. She burst out in tears. Happy tears.

Joanna sadly passed away earlier this year. She was a bright light, full of passion and magic and laughter. To me her work had a soft longing to it, a sense of the past and the feeling of another time. Her work will forever live on to inspire us all. You can still find her beautiful art at mosshill.blogs.com.

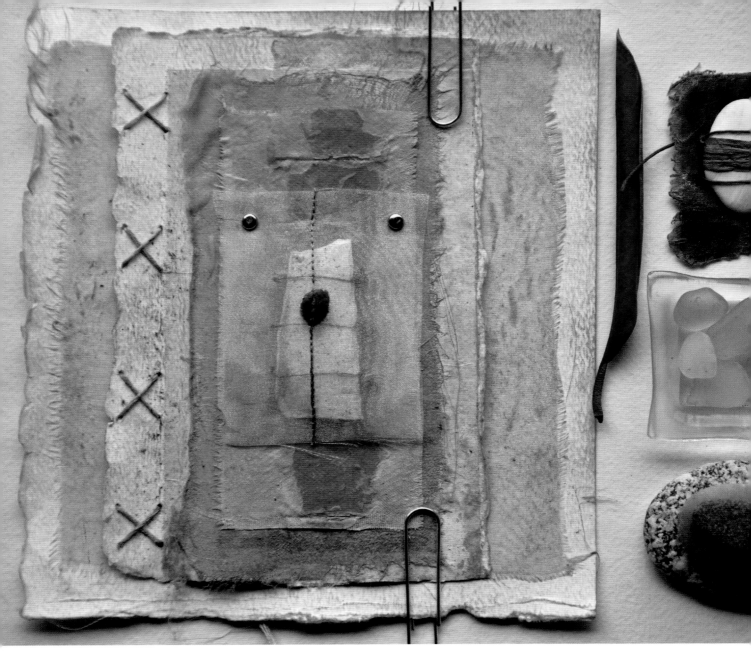

REMNANTS

Remnants reminds me of the coves of the Oregon coast where little creeks make waterfalls down the cliff sides and the pale greens, sandy browns and all the treasures one can find when the tide is out. Beside this piece I arranged a small stack of rocks, a bundle of sea glass on a blue glass plate, a brittle curled-up leaf and a piece of shell wrapped with seaweed.

CHAPTER 6
Collage with Nature

Study nature. Love nature. Stay close to nature. It will never fail you. ⤜ **Frank Lloyd Wright**

Nature is my favorite theme to collage, paint and write about. I have drawn and painted images inspired by nature since I was a little girl. Every time I drew something—even something as small as a seedpod—I would find myself completely absorbed in all of its details and colors. It was my way of claiming it, making it mine. In college I majored in biological illustration, and although my art has changed quite a bit since then, I still love the chance to draw and paint from nature.

I am entranced by the changing seasons. Each calls to me in a different way; the colors and the textures have a huge influence on all my art projects and creations. I've noticed how the colors of an old weathered leaf or a collection of some small stones can somehow become a main color in my collages, and often they end up on the pages of my journals or on a canvas.

When you are outside in the natural world during any season, do you love to sit still or quietly walk around your area? Listen intently to the sounds of nature and feel that sense of belonging, that beautiful sense of quiet. These moments guide and refresh us and spill over into our creative journeys through the days and through the seasons.

In this chapter you will see how to use nature in your collages, from trying to capture her colors to attaching natural objects and images to your work. And you will see images of my world, during this winter in southern Oregon.

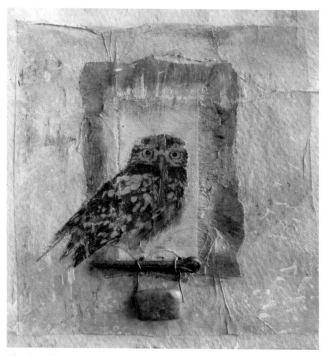

The book page with the little owl is one of my favorites. She is perched in a "window" and seems to be holding a rusty clip and a bead. Windows have an important role in my art, and I love to teach workshops around this theme.

Today on My Worktable...

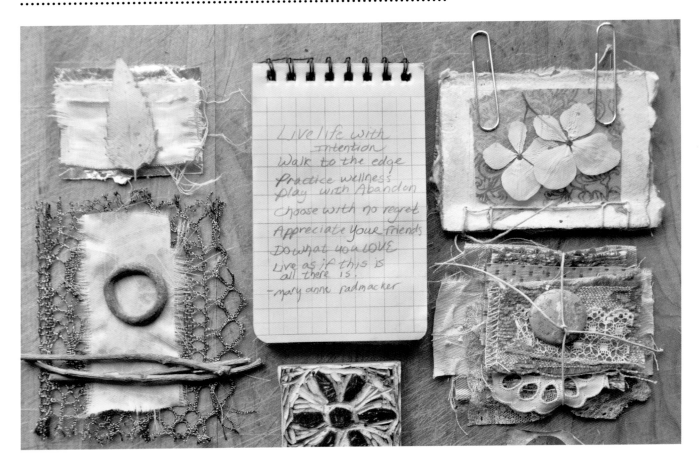

I love to arrange things on my worktables. In my studio I have three different surfaces to work on: an old butcher-block table on wheels, an old red tool cabinet that my husband made a wooden top for and my desk, which reflects light beautifully in the mornings or afternoons when I want to take photographs. Today in the center of my work area on my desk is a quote by Mary Anne Radmacher. It is one of my favorites and so perfect for this new year.

As you look around this arrangement, there is a small book that later I'll attach pressed hydrangeas to, a lovely pile of fabrics topped with a blue stone bead. Underneath the quote is a hand-carved stamp of mine, which I will be using in my Collage Challenge for this chapter. On the left side of this arrangement are twigs and a rusty ring lying on antique lace and vintage silk, and a yellow pressed leaf resting on blue fabric and a candy wrapper.

Nature teaches me—she gives me quiet.
She gives me hope and guidance.
When I am outside in my garden all of my senses are alive,
I feel connected to the earth.
»»» **Roxanne Evans Stout** (from a note to Tonia, summer 2013)

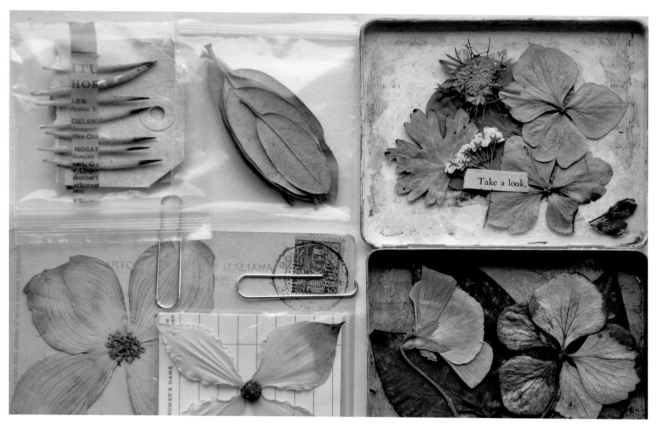

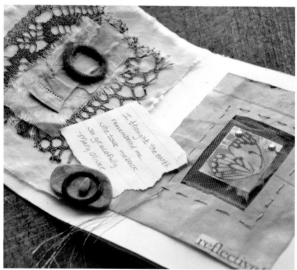

I press flowers and leaves and save them in tins, plastic or vellum envelopes and in books, especially when I'm on a trip with my husband. Whatever book I take to read in the car (usually art books!), often it is the perfect place to press a plant. My first experience with pressing plants was a field botany class I took in junior college. Our class made huge three-ring binders of all the plants in Southern California, going out in small groups in the early hours of the morning and collecting and studying them. It was a wonderful class!

Task

At night, go outside and look at the stars. Starting with the east, where the sun rises, say a blessing for each direction. Do this every night until it becomes familiar to you and you've memorized each blessing. Make this your own ritual.

Rise up to Meet the Sun

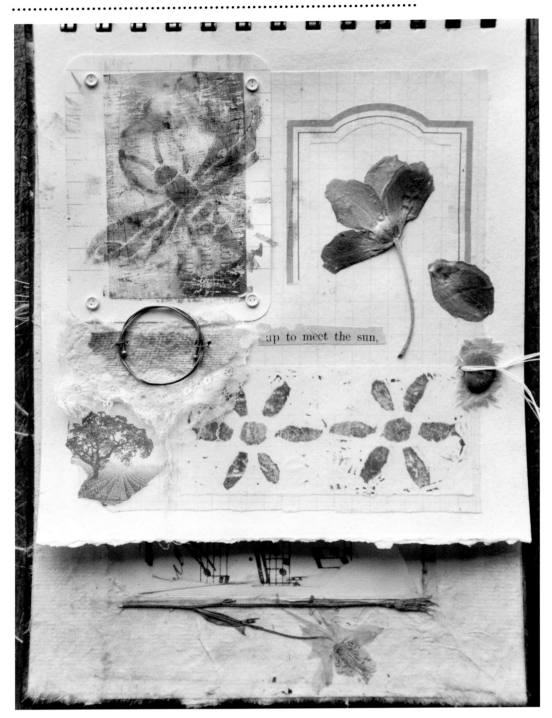

This collage is the story of a morning in the middle of winter when the earth is getting ready to wake up. It is a collection of different images and objects that seemed to just belong together. It speaks of not only my love for nature, but of how I love to move around and arrange things until they find a place to belong in my art and my home.

Think about winter and how underneath the frozen ground and snow the earth is resting, getting ready to awaken. What colors and images remind you of winter, and what do you see as you "rise up to meet the morning sun?" Include a favorite stencil or a stamp, a wine label and perhaps a pressed flower from another spring!

What *You* Need

- awl
- brads, small
- brayer
- candy bar wrapper
- craft glue
- Distress Ink Pad (Tim Holtz)
- glue stick
- hair spray
- hand-carved (or favorite) stamp
- images (from vintage book) and papers
- linen thread
- matte medium
- old paintbrush
- PanPastels
- paper towel
- pressed flower
- stencil (insect)
- stone, small
- straightedge
- vintage fabric or lace
- water dish
- watercolor paper or art journal
- wine label
- wire

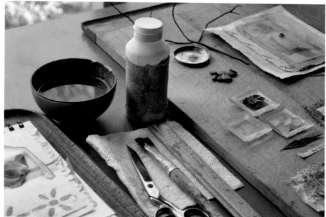

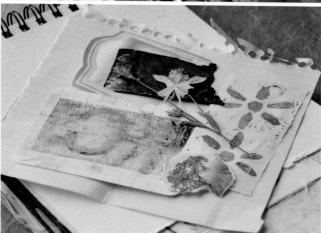

1 Gather supplies and begin arrangement

Gather your supplies, fresh water and arrange objects of inspiration on your worktable. Include things that might find a place in your collage because of shape, color or texture. Lay the background images down on your art journal in the way you want them to appear in your collage.

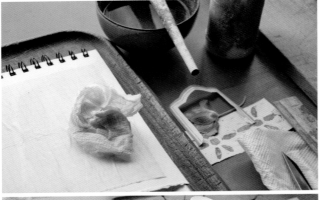

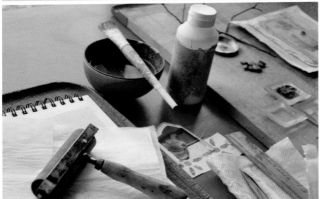

2 Adhere papers

With your old paintbrush, spread a layer of matte medium under your first paper and then paint a layer over it. Blot it with a paper towel and roll over it with your brayer to flatten and get air bubbles out. Repeat this process for the rest of your papers or images.

I used vintage graph paper for my background paper, and left some of the white watercolor paper showing around the edges.

3 Attach heavier paper with brads

Your collage should be coming to life now! Adhere a pressed flower with matte medium on both its front and back, then blot off the excess. Tear off the border of the wine label and use it around the flower and use part of the image somewhere else in your collage (I chose the opposite corner). Using a Distress Ink Pad, stamp an image on a scrap of paper, tear the edges using a straightedge and adhere it. Use brads to attach heavier paper.

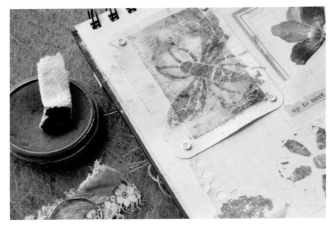

Find your light ... They can't love you if they can't see you. »»» **Bette Midler**

4 Use some stencils

Use one of my insect stencils from my Nature's Gatherings series or a stencil of your choice. Stencil over your candy wrapper using a small piece of paper towel and Pan-Pastels. Spray it with hair spray (fixative will also work here).

5 Embellish with wire

Begin to gather embellishments. Thicker wire twisted in a circle is always something I like to add to a collage to symbolize the sun or the moon. Use an awl to poke holes and attach your wire circle using small bits of wire folded as I did in this photograph. Under the wire circle add some interest with a scrap of old lace and even a bit of stained paper towel. I used a glue stick here to keep the texture of the lace intact.

6 Add a small stone

Lastly add a small flattish stone. A little craft glue will hold it in place as you stitch it to your collage with linen thread, and again, use your awl to poke one hole on each side.

Task

Gather your journal or a writing tablet, a pencil and go outside and find a place to sit where you are surrounded by the natural world. If you don't have a place near your home, go to a park. When you find a place to sit, breathe slowly and be conscious of each breath. Relax into yourself. Make a list of all the sounds you hear. This is my list:

Morning Sounds:
The wind through the maples.
Chickadees chirping.
A Stellar's jay calling her mate.
A faraway train.
The breeze carrying leftover leaves across the old bricks.
My breath.
The sound of my pencil as I write.
A neighborhood dog barking.
The closing of a door.
The whir of quail as they rush away from snacking on
 fallen birdseed.

What will you call this collage? What story comes to your mind when you look at it or run your hands over all of the textures? If you aren't quite finished, leave it out on your worktable until the right piece calls to you.

Windows on My World

A distant tree holds up the sky.
A windswept meadow,
coming close the night.
»»»Roxanne Evans Stout

Sometimes people ask if we will always live here. And I always say yes with sureness. Before I was even in the second grade, we had traveled and lived in many places including Europe and across the country. I often wonder if that is why home is not only so important to me and to my sister and brother as well. When we bought our ranch-style house, it was small but on the top of a hill with a little graveyard and forest behind us with a beautiful river view in front. It had high ceilings and big picture windows where we could watch the birds migrating through the sky.

As our family grew so did the house and gardens. Now we still watch the birds, but much of our view of the river has been obstructed by other houses. We still have that feel, a perch on top of our little world, the Pacific Flyway in the sky and the river and the smell of the pines

There is a bundle of wrapped shells gently placed over a copy of a painting my mother did of me, which I printed out and covered with a layer of wax. My mother painted me often, and I love to paint my daughter, Amanda. I often wish I could know what my mother saw in me, but I do know that I see a poetic quality in Amanda that maybe only a mother can see. The hydrangeas are from the Oregon coast.

Outside I like to use a glass patio tabletop to place my collections on. If I take the photo from a certain angle, the trees and the sky overhead reflect on the table. Wrapped stones are favorites of mine, whether they are attached to a collage or not.

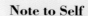

Note to Self

Remember to notice the little things, a color reflecting in the glass door of a cabinet, the draping branch of a tree or the simple leaf of a bamboo plant. Write about what you see. These little things make our world a beautiful place.

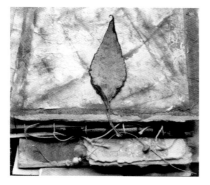

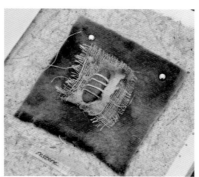

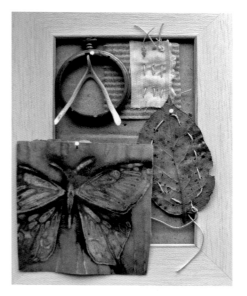

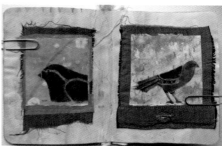

Kim Henkel

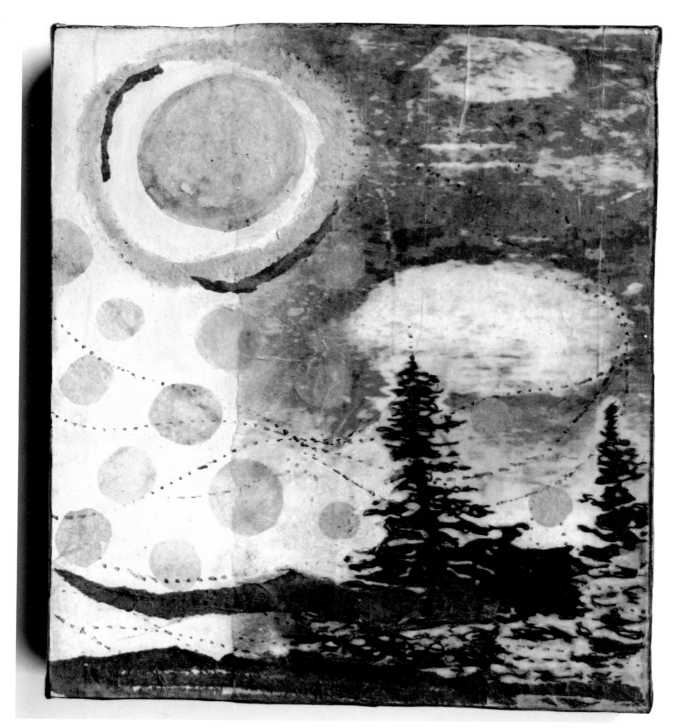

A Place to Wander
7" × 6" (18cm × 15cm)
Variety of papers (including tea bag paper), manipulated photograph, matte fluid
and gel medium, acrylic paint, PanPastels, spray fixative, blue ink, black ink, fine
black permanent pen, Dorland's Wax Medium on wood cradlebord

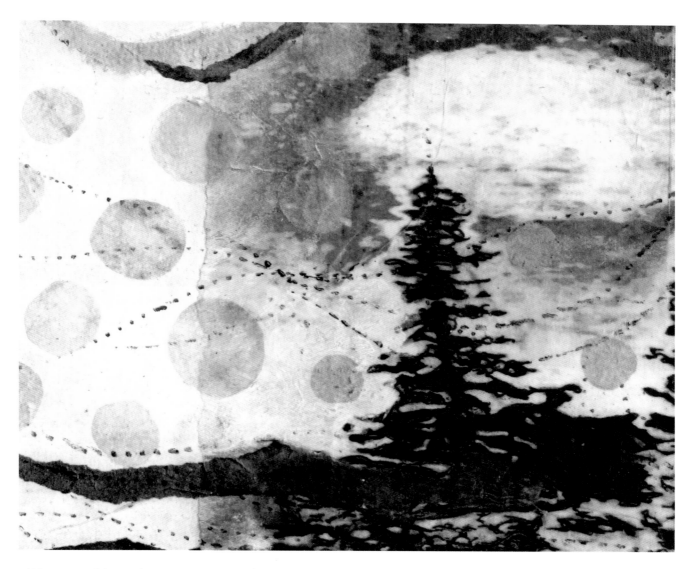

When pinned down, I have occasionally confirmed that I love to wander. I wander in nature, I wander in my creative endeavors and I wander in my thoughts. I especially love to wander when I don't know where I will end up or what problems or delights I will experience along the way.

This wanderlust began in the forest near my home. My daughter and I set out to enjoy the winter sun that came out only for a few minutes per day. We climbed over some downed trees and peered through the branches that occasionally obscured our view. We lay in the snow to adjust the scene and followed the raven tracks in the snow. We had to backtrack a time or two, as we were unsure in what direction we were heading. When we came home again, we had a smile in our hearts and another wander in our pockets.

And so it was with this collage. A creative wander from that day that also took me over some downed trees and along some wrong trails, but eventually I arrived at a place that tells this story.

Kim's work is soft and strong at the same time. She lives high in the Yukon Territory of Canada. I think because winter is so long there, she has a special relationship with light and color and finds beauty in the smallest details of nature. Visit her blog at khenkel.blogspot.com.

A COLLAGE STORY
Bee Shay
..................................

Stone Stories
4" × 9" × 2½" (10cm × 23cm × 6cm)
Waxed linen, antique bird print, antique typewriter key, newspaper, skeletonized leaf, small
piece of wasp nest, dried and pressed dogwood blossoms, hand-printed paper (mine), antique
photo cover, one-hundred-year-old pieces of letters and journals (personal collection), cicada
wings, pages from antique birding book, dried and pressed hydrangea blooms on mica

Having moved in recent years, I've been feeling a bit homesick of late, pining for the large trees in vast wooded areas that I don't have anymore. I felt ungrateful for this. I live in a wondrous place on an island thirty miles out to sea off the coast of Massachusetts, where natural wonders surround me every day. My thoughts were to capture a bit of home and work through my feelings so I could go about the business of moving forward and enjoying what was at hand.

In southeastern Pennsylvania, my family home, where the first eighteen years of my youth were spent, was built on an old bird sanctuary. Being surrounded by woods and birds and insects was an incredible way to grow up, especially in a time when children were allowed to disappear out the back door after breakfast and not come home until dinner was on the table.

Spring was always magical in the woods, bees humming and working on their honey crop, birds flitting about gathering and nurturing their young, trees popping into color. The world was constantly changing and becoming—moving toward summer and autumn with a relentless pace. If you weren't careful and didn't observe everything, you might miss something.

When thoughts of how to structure this little book were being pondered, the use of mica became a clear choice. We children used to find it and spend hours peeling away the layers, so it seemed only natural now to use it to capture memories. The hardest thing was choosing what was not going to be included. Wanting to keep it as simple as possible, like childhood, the paring down began. Once the choices were made the becoming of the book was magical. Once again, I was a child spending my days in the woods behind my home, gathering, constructing, imagining and playing. Homesickness at bay, I'm left with a sense of accomplishment and something to share with my grandchildren about how it once was when I was their age.

Mica pages encapsulating natural found objects, paper ephemera and memories of youth.

Bee has a beautiful sense of design and is always learning new ways to express her love of nature. She is an active member and president of the Nature Printing Society where she shares her passion with other nature lovers and printers (natureprintingsociety.org). You can see more of Bee on her blog at beeshay.typepad.com.

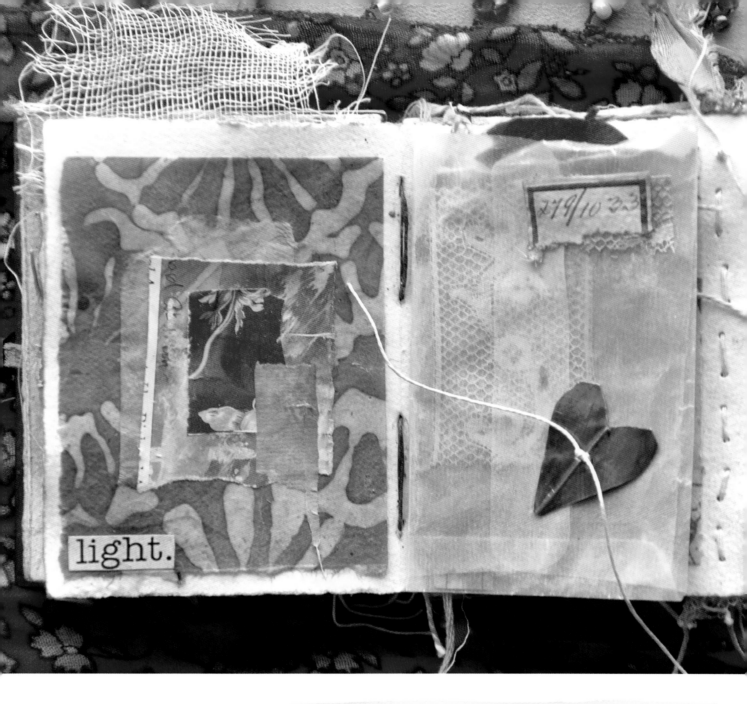

light.

PIECES OF LIGHT

I created this two-page spread in a book made by book artist Leslie Marsh. She sent it to me to use as a sample for a workshop we were teaching together. I couldn't resist working in this lovely, little soldered-metal book again. Leslie and I still teach together, and those creative days are high points of my year. I hope our students feel the same way!

As I wrote and made art for this chapter you will see that I had been thinking a lot about light: How filtered light plays on my photographs, how to share your own light and how without light there would be no color. I was playing with reds and blues here and simply laying color scraps on top of each other until my collage felt finished.

I attached a little glassine envelope on the right page. Inside it is a piece of light blue rice paper and a fragment of vintage lace. Part of its label and a little brass heart are attached on the outside. I love using an element of surprise in my collages, and small objects from my worktables will often later find homes in my work.

CHAPTER 7
Collage with Color

We are all mosaics—pieces of light, love, history, stars— glued together with magic and music and words.
»» Anita Krizzan

Growing up in Southern California the colors around me were lush greens, deep-ocean and sky blues and exotic tints of every flower imaginable. But I don't remember the colors changing with the seasons very much in Southern California, and I don't remember being influenced by them as much as I am now. Perhaps that is why I love living in Oregon. Here our colors are often more subtle and change with the seasons, and here the seasons are very distinct.

Now with the approach of spring, touches of yellow, pink and lavender appear. The grass in my front yard is its brightest ever, almost achingly so, and the first tiny leaves on the trees shimmer in the low morning sun.

I love noticing how the colors in my garden change with every season.

In the summer my shady gardens show off vivid reds, purples and magentas. Our greens are a mixture of the soft or vibrant leaves of the deciduous trees and darker, deep greens of the pines.

Autumn colors are the ones that show up the most in my art, and this has long been my favorite season. I love autumn's golden browns, red-oranges and yellows, ambers and crimsons and deep wine-reds.

In the winter the hues are softer: heather green, light ochre, browns tinted with blue and gold. I love to use these colors in my art. But more and more often lately I find that I have to add brighter accent colors to my collages, especially before spring, when I am searching for color.

Discovering the symbolic meaning of colors in other cultures has always been fascinating to me, especially in our Native American culture. And I like to adapt my own interpretation to what I find.

Here is my chart of what colors symbolize to me:
Blue - Wisdom and intuition
Red - Happiness and faith
Yellow - Courage and light
Orange - Uplifting and rejuvenation
Green - Nature and harmony
Purple - Mystery and magic
Turquoise - Calmness and peace
White - Light and purity
Black - Strength and confidence

Today *on* My Worktable...

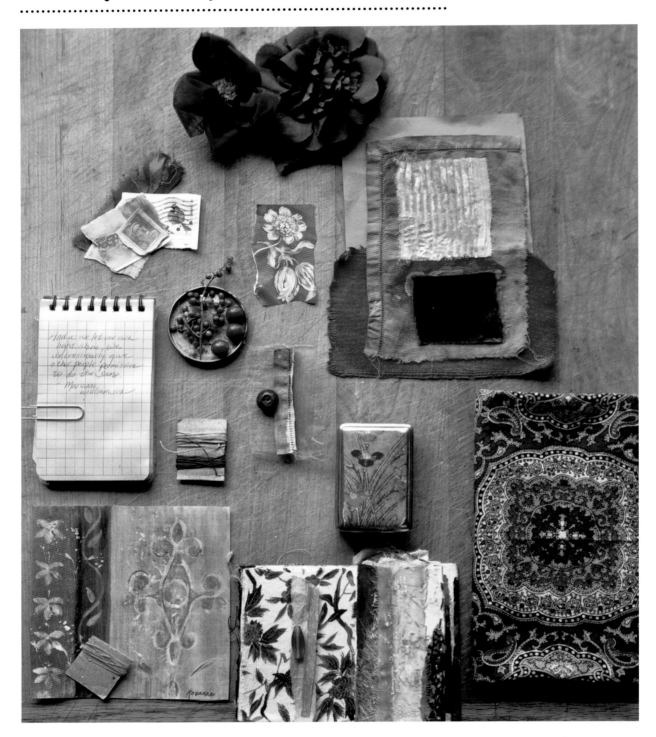

And what is it to work with love? ... It is to charge all things you fashion with a breath of your own spirit. »» **Kahlil Gibran**

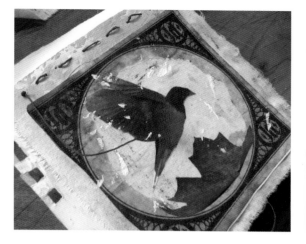

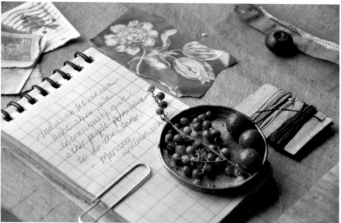

Task

Sometimes I think an unfinished collage or painting is just as beautiful as a finished creation. To me, art in an early stage can really show how the creative process is unfolding, and that is very worthwhile to capture in a photograph.

Take a sequence of photographs of a collage that you are working on: from the beginning starting with your pile of scraps to your middle stages and finally to when it feels complete. Print out your photographs, cut them out and write down what you see.

On my worktable today is a celebration of color! Bits and pieces of fabric, scraps of paper and pieces of nature. As your eyes move around this photograph, is there anything that especially pulls you in? For me, my eyes move around my worktable as if it is itself a collage or painting, starting with the silk flowers at the top. Next they circle around until they come to the handwritten quote, and I take a moment to read the words silently to myself. My eyes move into the center of my arrangement and finally soak in the other details one by one.

"And as we let our own light shine, we unconsciously give other people permission to do the same."
—Marianne Williamson

There is something about this quote that has resounded in me, over and over, especially during the last few years as I teach workshops and create art.

When I go into my studio I am giving myself permission to play, to create, to find my own light and my own way of creating. And when I teach I am helping other people find their own light and way of creating as well.

Gowns of Golden Grace

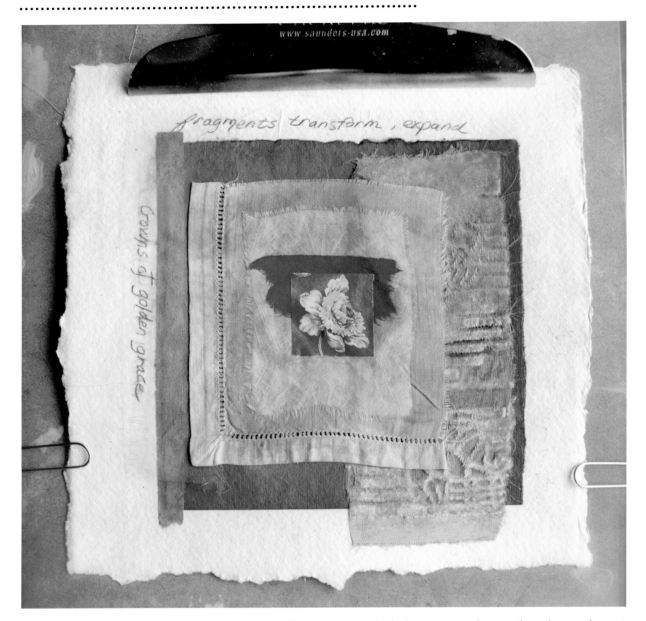

Gowns of Golden Grace makes me imagine a beautiful vintage velvet gown in front of a background scattered with reds and blue-greens. The gown might have been worn in the eighteenth century, with a big bustle and tight bodice and flecks of gold attached to the skirt.

This collage is made of papers and fabrics that I dyed myself. I had gone to a workshop in the Santa Cruz Mountains, where we learned shibori dyeing techniques taught by Sharon Kilfoyle, and I spent my time making color squares that I could use in my books and collages instead of dyeing garments and scarfs. Turquoise and red-oranges have really been calling to me lately, so these were the colors I wanted to use for this challenge.

Think about some colors you love that you haven't used for a long time, or even try a new color palette for this next collage. After you choose your colors, begin this collage by tearing your watercolor paper into a square rather than cutting it with a knife. Do this by laying your straightedge over the top of your paper and painting several layers of water over the line you want to tear. Pressing down the ruler with one hand and tearing softly down the page—outward instead of straight down—will ensure that your line is soft.

When you tear lightweight fabrics, cut a slit where you want your tear line, then pull the fabric apart beginning at the slit. Make your papers and fabrics different sizes to add interest to your composition.

What You Need

- hair dryer
- matte medium
- old paintbrush
- paper clips, jumbo
- pencil
- straightedge
- textured fabric and paper squares of complementary colors (yellow/purple, green/red or blue/orange)
- tissue paper
- watercolor paper, 140-lb. (300gsm), 7" × 7" (18cm × 18cm)

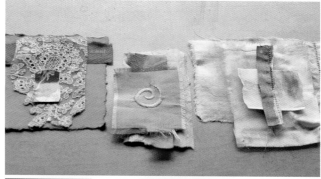

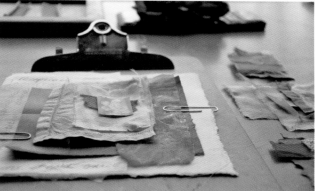

1 Gather scraps in complementary colors

Collect colored pieces of paper and fabric or images. This time, search your boxes or drawers for colored scraps of paper and fabric that are complementary, those colors opposite one another on the color wheel.

Make three or four bundles of your papers and fabrics that go well together and choose the one you want to make today. If you love them all, like I did, paper clip the bundles together to save for a later date.

Task

Research the symbolism of colors and then think about what the colors mean to you. Do they evoke certain feelings or hold a special memory? Make your own color chart!

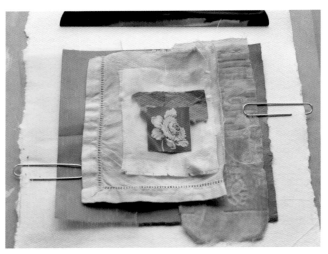

2 Decide on your composition

Play with design using different colors in different areas of your paper. Choose one larger piece of paper for your background, then decide on a focal point, maybe a piece of fabric or paper with an extra texture or pattern, or a torn portion of an image or painting.

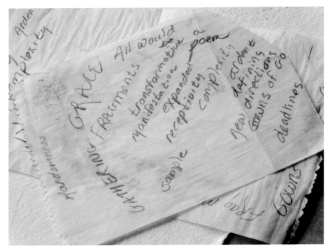

3 Write words on tissue paper

Write random words around a piece of tissue paper. The paper should be a little larger than your collage design so the words will show in the background.

The words I chose here came from a writing activity I mentioned earlier. We collected words from old poetry journals and randomly put them together with other words that we wrote on loose sheets of parchment paper.

You can see the words I collected; I wrote them again down the sides of a different sheet so the words would show around one side of this collage.

4 Adhere the tissue to watercolor paper

Apply matte medium to the watercolor paper and gently adhere the tissue paper. Brush additional medium over the tissue, taking care not to tear it in its wet and fragile state. Gluing it down makes the tissue almost invisible.

5 Add background paper

Using matte medium, adhere your background paper over the tissue paper, being mindful to not cover up your words.

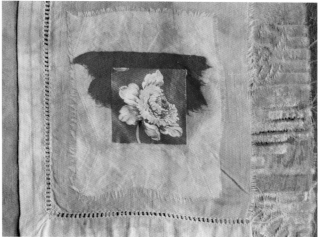

6 Build layers

Begin to add your other layers, drying with a hair dryer between each one. If you use fabric, leave some edges dry and unglued. If you use velvet, try to keep the matte medium just on the back side so the fabric's softness to the touch remains unaltered.

In our life there is a single color, as on an artist's palette, which provides the meaning of life and art. It is the color of love. »»» **Marc Chagall**

7 Finish with focal points

Lastly, adhere your focal points over the top of your layers. Here mine is somewhat centered, but you don't have to center yours. Experiment with different placement until you find the composition you love.

Windows on My World

Clouds come floating into my life, no longer to carry rain or usher storm, but to add color to my sunset sky.
»»» Rabindranath Tagore

As I write today it is stormy outside, the February sky is painted in every shade of blue, and the roads are shiny and black from heavy rains. The colors of my world outside are dark blues and greens and browns, not the colors of spring and summer that I long for. At this time of year, dramatic skies are often the only contrast in a world that is dominated by shades of gray.

I sit at my desk and gaze out the window across the river to the east as I always have.

My eyes sweep across the landscape and I try to memorize the colors of the land where I live. I love the colors of the red branches of dogwood along the wetlands and the tips of yellow on the willow trees that change almost weekly now that we are approaching spring.

Note to Self

Searching for color . . . I think winter is the most important time to find color—both inside and out. Outside colors can be more subtle and harder to notice. Sometimes you need to look closer and use your imagination, similar to when you boost a color in a photograph.

In my search for color, I find papers that I dyed myself, and my traveling watercolor paint box outside on the round glass table, my Twinkling H2Os and my Caran d'Ache crayons. Can you see how the light seems to make these photographs glow? This is the light I love.

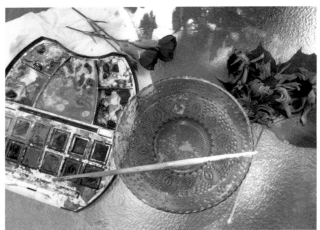

Task

Make a list of colors that you can see from your kitchen window. How do they make you feel, and do you use them in your art?

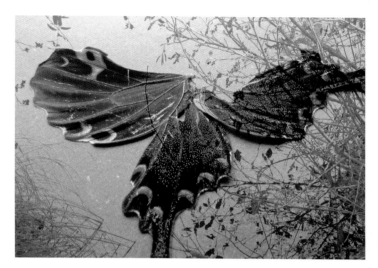

I hope that these photographs will give you a glimpse into the color I am finding in my world. The butterfly wings photograph is actually made up of two different images. The wings are from my own collection, and I took their picture in a silver tin box. If you look closely you can see the glittering spatter of colored dust that is still on the wings. Using Adobe Photoshop, I overlaid the wings image on a photo of a mountain pond that I had recently discovered. On that day, the water reflected the graceful branches of river birch and willow as if it were a mirror.

African violets bloom here indoors every winter, and on this day I wanted to photograph them outside on my front deck. To me the yellow and pink and green are stunning together, and you can see tiny green buds on the mountain ash tree.

Fresh flowers indoors are always something I love. We just get them from the market, but in larger cities there are many specialty stores that will sell you a bouquet of flowers. They looked extra beautiful in front of this old tin siding.

My little brightly colored purse, a gift from my husband, is so colorful that I just had to use it as a backdrop for these dried flowers. You saw both of these earlier in this book when they were much more alive!

Ro Bruhn

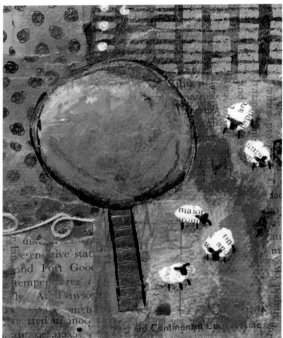

Dreaming in Colour
10" × 8" (25cm × 20cm)
Acrylic paints and inks, variety of my hand-decorated papers, gel medium,
hand-dyed thread, soft pastels, spray fixative and matte sealer on wrapped
canvas

Over the years, sheep, houses and "lollipop" trees have become regular features in my paintings. Originally, I worked in pastels, where these things made their first appearance. Then I started using acrylic paints and adding collage papers, and it wasn't long before they started showing up again. They now appear even in my fabric journal pages. I have a passion for colour and circles, so that explains the lollipop trees; I'm not so sure where the sheep-and-houses influence comes from, maybe my early days as a child in the UK!

I love Ro's playful and colorful approach to her art making. Her colors are full of energy! Visit her blog at robruhn.blogspot.com.

A COLLAGE STORY
Stephanie Hilvitz

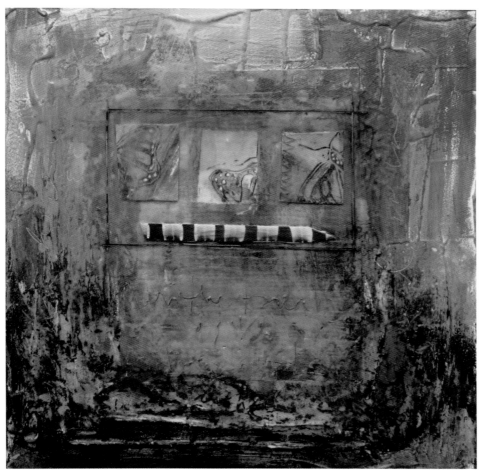

Monarch Musing
12" × 12" (30cm × 30cm)
Original photograph, paper, acrylic paint, machine stitching, water-soluble crayons, hand-carved stamp, beeswax on wood substrate

I have been under the spell of the monarch butterfly for some time now, its mythology, lore and science feeding a rich and varied creative vein. *Monarch Musing* is part of a series of portal works based on the lore of the monarch; the portal being the connection between the living and those that have passed. The indigenous peoples of central Mexico believed the yearly migration of the monarch butterfly to be the souls of their loved ones returning home. Some say the celebration of Dia de los Muertos was born in Michoacán of this belief.

Each piece is first layered with words that disappear within the work, the essence of which embeds a story that is pulled out further with imagery. As the layers progress, other words are etched into the surface, not meant to be deciphered but to add a layer of texture to the image.

The story running through my mind as I created *Monarch Musing*: mining for mystery, petroglyph-like surfaces, emerging in the portal. "Follow me," she says, "flash through this ancient portal, these migration tales."

Stephanie has wonderful projects, often including the monarch butterfly, that she creates for herself and her community in her Mango Studio. You can see more of Stephanie's work on her blog: rodrigvitzstyle.typepad.com.

A COLLAGE STORY
Tracy Verdugo
..

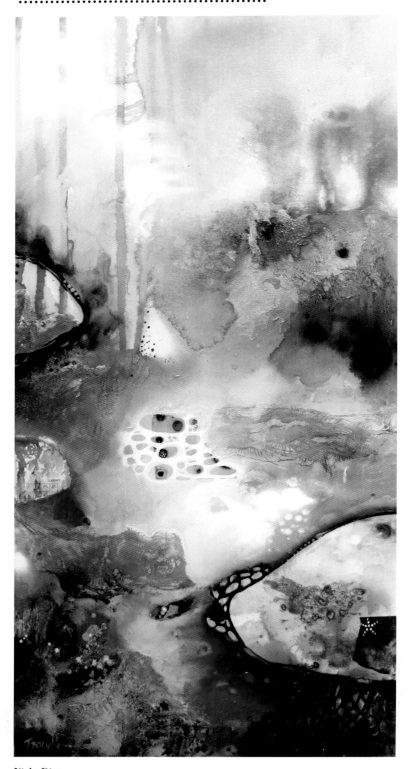

Night Dive
35" × 17" (90cm × 45cm)
FW Daler-Rowney inks: Marine Blue, Payne's Grey, Flame Orange, Antelope Brown,
Waterfall Green, Indigo and White, sea salt, collage elements: netting, gauze ban-
dage and magazine images on stretched canvas

It's almost pitch black and I am hanging onto the side of a boat in the middle of the ocean off the east coast of tropical North Queensland, Australia. The surface of the water is not calm this dark night, and small waves come out of nowhere and slap up against my face. My emotions match my physical surroundings, and I am wrestling with a panicky impulse to forget the whole thing and climb back into the boat. I have spent most of the previous night and day trying to come up with excuses not to join in this experience that the rest of the dive students seem so eager for. My breathing is fast and heavy, amplified even more by the feel and sound of the regulator in my mouth. I fight the fear, look into the encouraging eyes of my love, and we both sink downward into the watery depths.

Beneath the surface everything changes. I am greeted by magic: a fantastical, dreamlike world; a cornucopia of color and design; and pulsing fluorescent life. Everywhere I look there is something to enchant me. Luminescent greens and pinks, dancing, breathing corals and shimmering fish darting in and out of swaying anemones. Silvers, purples, vibrant oranges and lemons, every pattern imaginable. The perfection of nature is unveiled as I swim forward into one entrancing scene after another.

My eyes are wide but not with fear. Even a sleeping reef shark nestled up against a rock shelf is a thing of wonder. I am at one with the world around me, and these memories will never fade.

Tracy's work is enchanting and vibrant, just like her! You can see more of it on her blog, artoftracyverdugo.blogspot.com.

A COLLAGE STORY
Jill Zaheer

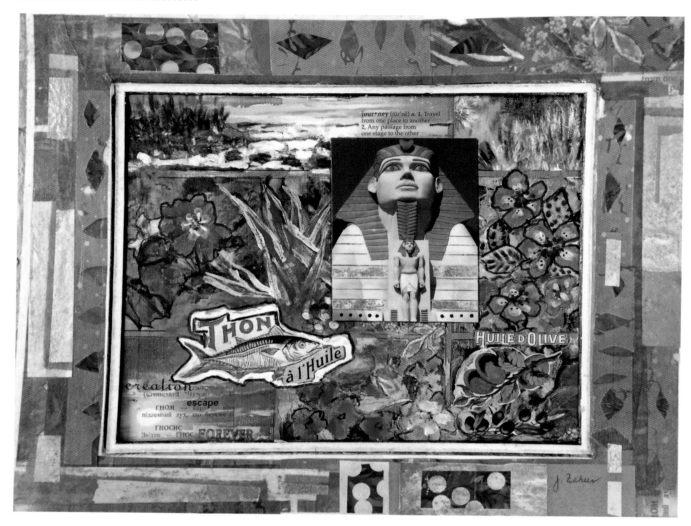

Limited Edition

11" × 14" (28cm × 36cm)

Prints of photos from Cape Cod, photograph of a sphinx in front of the Luxor Hotel in Las Vegas, old French product labels from a cookbook, small piece of tapestry from my mom, colored papers from artist swaps, acrylic and watercolor paint, correction fluid, black permanent marker, colored yarn, tissue paper, rub-ons, rubber stamping, old French food labels on watercolor paper, in cardboard-matted photo frame

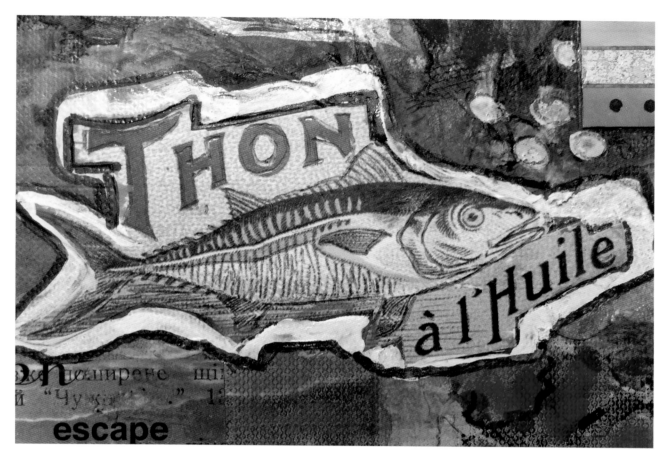

This work was inspired by a trip to Cape Cod, Massachusetts, this summer. Drawn to color, there were breathtaking "picture frames" from one moment to the next: green grasses of meadows, blue waterways and brilliant hues of reds and yellows as the sun set. There was always the feeling of being on a journey.

No matter how many times I may have visited a particular place, I was constantly amazed at the unseen sights I would discover and details I would uncover.

The process of this work began with a base of seven prints of my favorite photos from the trip, accented with multiple layers of paint. Colored papers were incorporated from fun and fabulous paper trades. It's my way of feeling connected to my artist friends even though we may not be in contact with one another as often as I would like. Embellishments of materials, rub-ons and French food labels were then added.

Most of my artwork includes items with special meaning to me, and this work is no exception. Included is a tiny piece of needlework sewn by my mother and the sphinx photo was one I took in Las Vegas when celebrating my father's eighty-fifth birthday.

My works are in many ways visual adjectives created from words, images and feelings, which are expressed through design. For this piece, my goal was to create a colorful kaleidoscopic work. There is something very magical about the process, always generating a flow of energy, free in spirit and free in mind.

Jill's collages are energetic and alive with stories. See more of Jill's work at jazworks.blogspot.com.

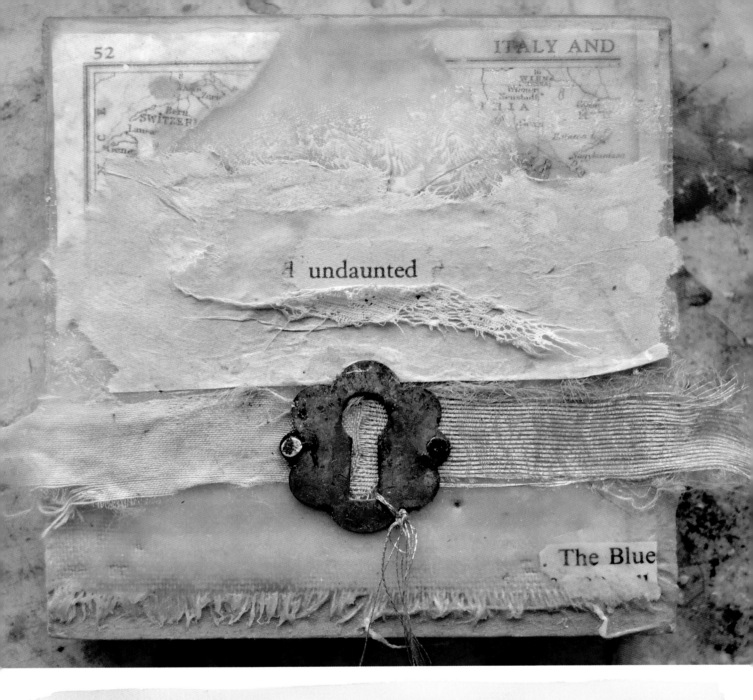

UNDAUNTED

When I worked on this collage, I was thinking about how much in our lives can be daunting. Sometimes it's hard to rise up out of the feeling *I just can't do it*, and charge ahead. I've realized that even if our dreams seem lofty, to pursue them a little bit at a time will make us feel proud of ourselves and feel a sense of accomplishment. We will be "undaunted" as we pursue what we want for our lives.

Chunks of discarded wood make wonderful surfaces for encaustic collages, and this little one is no exception. I adhered parts of an old map of Italy onto its two top corners and blue and white strips of fabric onto the foreground with matte medium. I added several layers of beeswax over the whole surface, fusing between each layer. After I had about eight layers of wax, I laid more papers and lightweight fabrics down one at a time, this time heating the wax so the pieces only partially "melted" into the background.

I found the little brass lock at an antique store in Eagle Point, Oregon and adorned it with a piece of golden thread. My father's ashes are buried there at the military graveyard, and we like to make a day of it when we visit. The words *undaunted* and *The Blue* seemed to fit perfectly, one in the center and one off to the right. Notice how the text *The Blue* is covered with a layer of wax and *undaunted* is not. I like to have different textures on my pieces and they are always touchable.

CHAPTER 8
Collage *with* Wax

·······································

As I began to write this chapter I had just returned home from teaching a workshop in beautiful Portland, Oregon. My students were wise and thoughtful, spontaneous and intuitive, but also loving and careful in what they added to their book pages. Like many artists I usually work alone, so being among other artists always refuels my spirit and teaches me new ways to look at my own art.

As much as I thrive during time shared with other creative souls, I also love my days between workshops because it is my time to work on my own art and writing. During these days when deadlines are far away, my mind is filled with images of what I want to create, how I want to photograph my projects, my world at River Garden Studio and different things that I want to write about. Ideas for art even fill my dreams.

I discovered encaustic painting one summer when I went to Encausticamp in Salem, Oregon, organized and created by Trish Baldwin Seggebruch. My teachers were incredible, including Bridgette Guerzon Mills, featured in this chapter.

While I don't consider myself very advanced at encaustic painting, for I still have so much to learn, I do love it and I experiment all the time.

Many encaustic artists use encaustic medium, but I prefer beeswax. Encaustic medium is made with dammar resin and beeswax. It takes longer to heat and also has more fumes. There is something intoxicating about the sweet smell of beeswax. I also like to mix it with encaustic paint, rather than use the colors as they come, to soften them and make them more transparent.

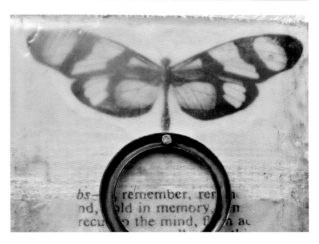

In these encaustic paintings you can see how I collage with all of the things I love, images and found objects, and how I use them as accents or backgrounds. Collage and encaustics go together so well. Papers can become transparent when they are dipped in wax, and there is a mysterious quality to all the layers.

Today on My Worktable...

Listen to the night as the night knows your truths, your stories, your aches, your dreams, your cravings, your forgotten memories, not so forgotten. »» **Victoria Erickson**

These camellias were a gift from a friend. As you might have guessed already, I am as entranced by flowers that are old and withered, as by those that are fresh and just blooming.

When I started to move things around on my worktable, I was thinking of the theme "Ticket to Anywhere" and a story slowly emerged. I added the golden cicada wings for a touch of whimsy and to give the feeling that anything is possible.

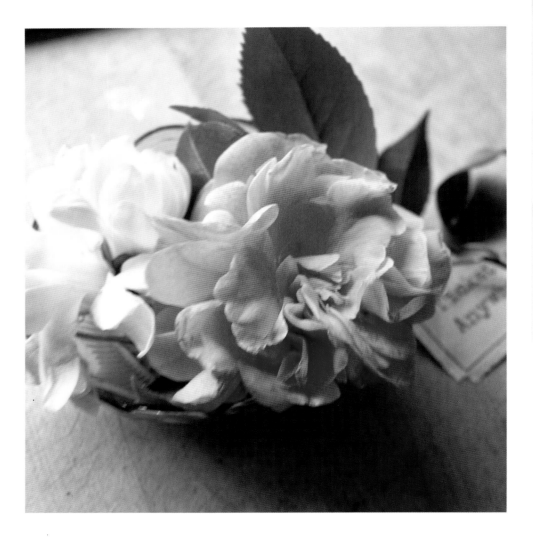

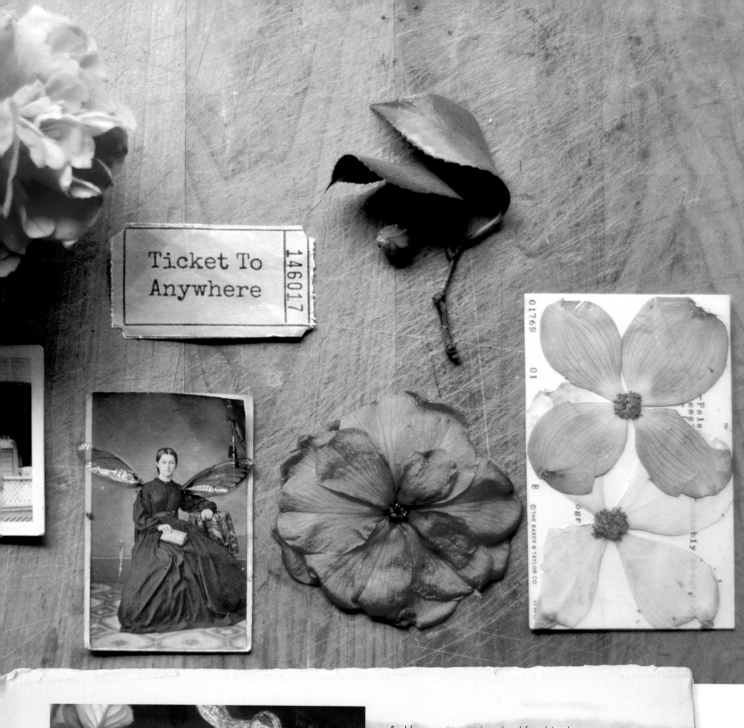

Ticket To Anywhere 146017

As I began to get inspired for this chapter, spring blossoms were everywhere, especially in places to the north and west of where I live.

I have a botany background and flowers are beautiful to me for so many reasons including their intricacy and the complexity of their structures. I include them in my still-life photographs because they give me a sense of what is happening in the world of nature and what season it is.

April Rains *and* These Days

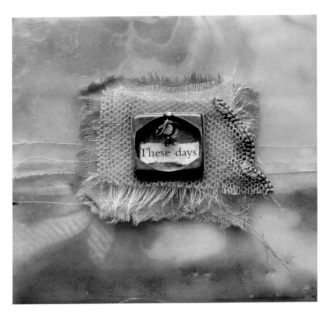
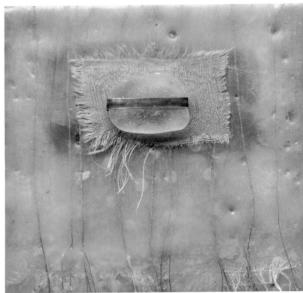

For this challenge I am sharing how I create two different collages, *April Rains* and *These Days*.

Because they are small, I wanted to go over different techniques for each one. *April Rains* is a softer version of the approaching spring, and *These Days* has a more vibrant and vivid feel to it, bringing to mind yellow and red tulips, daffodils, the pale greens of the first tiny tree leaves and the blue, blue sky.

What do the first rains of spring mean to you? What are the colors of your world when the ground is soaked and the leaves are wet and shiny? For this collage, think about the thirsty earth soaking up the rain and the flowers that will soon emerge.

When you gather things together for this challenge, remember that wax surfaces often have a misty, watery look to them. What can you add to the background that will show only partially, and what found objects could you use as focal points? If you would like to add many layers behind your objects as I did, tear or cut each piece a little smaller than the first, using the largest one first and building from there.

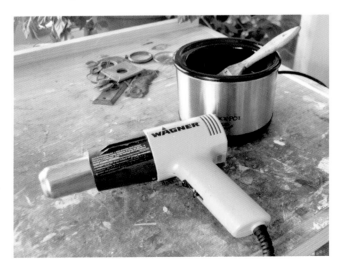

Before You Get Started . . .

To be safe, always make sure that your Crock-Pot stays at 175° to 200° F (79° to 93° C), and unplug it right away if it starts to smoke. Never leave it unattended. Work in a well-ventilated room—open windows and/or turn on a fan. Before you begin your first project, you might want to research encaustic painting in books and online and take special note of the precautions and procedures.

What *You* Need

- beeswax, white
- brayer
- bristle craft paintbrush, 1" (25mm)
- clipped text
- embellishments for focal points
- fabric and paper scraps, torn into 4" (10cm) strips
- hammer
- heat gun
- lace, tattered
- matte medium
- mosaic glue
- PanPastels
- paper towels
- rice paper
- rough sandpaper
- small Crock-Pot
- small nail
- straightedge
- thin metal strip or wire
- thin metallic threads
- wax or parchment paper
- wood blocks, approximately 4" × 4" (10cm × 10cm), 2

To me, it is always magical watching the wax colors change in their tins as they melt and turn into hot liquid, then the way they change again as they cool. When I first discovered encaustic painting, I was in love. I bought my supplies bit by bit, building up colors and tins and carving tools.

Inclusion Ideas

Experiment with a variety of inclusions in your wax layers. Some great things to use in your encaustic collages:

- oil paints
- PanPastels
- sprinkles of sand or rust
- thread
- photocopied images or images from magazines
- ink
- stamped images
- rice papers
- fabric and lace
- pressed flowers and leaves
- wire
- found objects

1 Prepare wood for painting

Sand your blocks of wood just enough to smooth out the sides if they are rough. Clear off a surface to work on and place your wooden blocks on a clean paper towel. This will soak up any wax that drops off your wood. I also like to work on a project board, which can be anything like a tray; mine is an old plastic cutting board from the kitchen.

2 Begin adding wax

Heat your pieces of wood until they are slightly warm to the touch. When the wax in your Crock-Pot has melted, paint a layer in one direction across the surface of each. With your heat gun set to low, heat or fuse your layer until no brushstrokes show. Wait a moment and then paint a new layer in the opposite direction. Fuse this layer with your heat gun. Continue this process until you have several layers.

3 Layer on fabric

Play with placement of your torn paper and fabric pieces until you find a composition you like. On one piece of wood, heat your surface again slightly with the heat gun. For lightweight fabric, lay it down gently on the warm surface. It will begin to soak in the wax. Fuse it.

4 Layer on paper

You may need to sand heavier paper on both sides to make it thinner and more porous. For the other piece of wood, heat the surface slightly, press on the paper, add additional wax on top and fuse again.

5 Add metallic threads

When your surfaces are warm but not hot, lay some metallic thread onto your projects and press lightly. Roll across your pieces lightly with a brayer. Use a paper towel or wax or parchment paper in between the brayer and your collage. Paper towels leave a slightly bumpy texture, but parchment paper will keep the texture smooth. I like both effects.

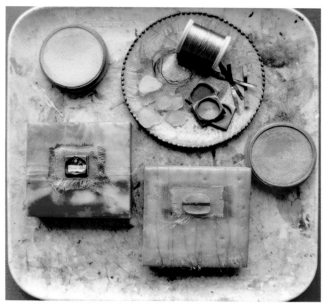

6 Decide on focal points

Decide on what focal points you want to have and lay them out on your worktable.

Option One

For *April Rains*, I used a scrap of fabric to provide a background for the sea glass. If you are doing something similar, first fray the fabric edges, then adhere the embellishment slightly with matte medium, so you are still able to see and feel its texture.

Wrap your embellishment with a thin piece of brass or wire. Use the flattest side for the back, and use mosaic glue to adhere it to your collage. Tint your edges with PanPastels. Rub the pastels on with a small piece of paper towel and then fuse very lightly.

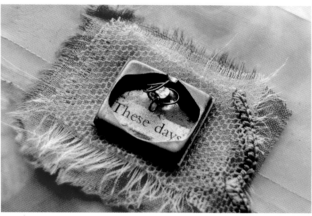

Option Two

For *These Days* I chose a small watch part for my focal point, but any little metal object would work. I also found the words *These days* in an old paperback book and cut them out. Using matte medium, adhere your text first onto the found object, then drill or hammer a hole in its top center. Place it over some colored rice paper and tattered lace, and hammer it into the wood. Add some twisted wire and this piece is finished!

Did your two collages have similar colors or themes, or were they completely different? And did you experiment with completely covering some papers or fabrics with wax and leaving some partially exposed?

Windows on My World

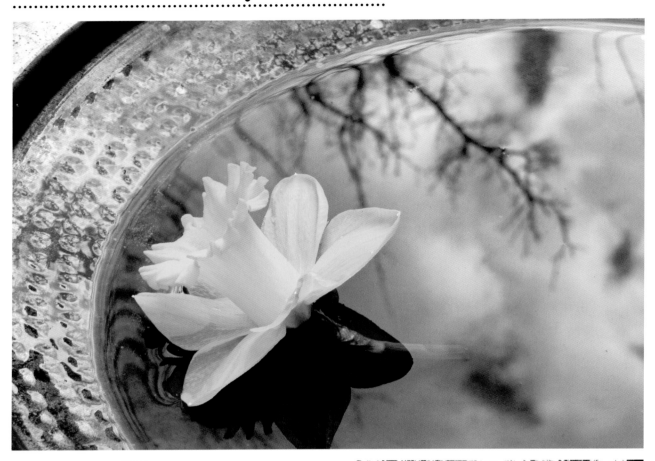

I look outside my studio windows and see the grass and trees and flowers coming to life. We have had several days of rain, and the thirsty gardens are getting ready to celebrate. Daffodils are blooming and buds are plump on the trees and bushes. The March skies are filled with puffy clouds, and the wind blows the branches on the trees and the tall grasses outside my studio window.

On days like this, one moment I'll be outside in a sheltered spot in the sunshine, then I will be sitting at the dining room table looking through art books in a sunny corner, then I will be back in my studio, painting and collaging my heart out.

For the first time this year I got to see a few dozen white pelicans fly over our house, gliding in one slow line in the wind current, always in synchrony. To me their return symbolizes springtime and the life returning to this land. They gracefully ease me into this new season.

Note to Self

Searching, always searching . . . but for what? For beauty, I think, a quiet beauty that is also passionate and alive with hidden layers and mystery.

And I am searching for myself. There are some days that I think more about making art than actually doing it, and on these days my thoughts are like a long poem. Words, groups of words, phrases, all of them tell the story of this moment in time.

Task

Think about what story you are telling with your art, with your whole collection or an art journal. Have your stories emerged? Write about your art on a page in your art journal. Then cover your words up with a collage. The story will always be there.

Bridgette Guerzon Mills

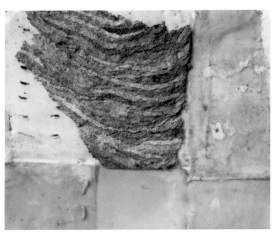

I love the moodiness evoked in Bridgette's encaustic collages. Her colors and her themes are powerful and soft at the same time. You can visit her blog at guerzonmills.com.

The Secret Self
16" × 12" (41cm × 30cm)
Encaustic medium/paint, book pages from an Italian architecture book, thread, paper from a wasp nest, ink-jet photo of an owl butterfly (altered first on Instagram), lokta paper, papers painted and drawn on with India ink, copper sheeting, black tack nails, encaustic monotype on rice paper on cradled birch panel

It has become a daily habit for me to take photos and manipulate them on Instagram. When I took a photo of the owl butterfly and altered it through filters on my phone, I knew that it was just the beginning of the journey for this photo. The owl butterfly is known for the markings on its wings that look like the eyes of an owl and keep it safe from predators.

Nature is the most magnificent artist and I am constantly inspired by the creations that are made by some of the smallest creatures. When I add bits of this and that to my paintings, it really is not a planned creation. My process is about touching the paper, laying things down, adjusting here and there until it pleases my eye and my hand.

As I was working on this, creating a layered and textured surface, I knew that I had found the place for my butterfly image to finally rest. I added the copper sheeting at the bottom as I am drawn to the contrast between the soft wax surface and metal. The patina of the copper adds to the feeling of the passage of time and nature's power to alter and shape us.

A COLLAGE STORY
Mary Beth Shaw

To me, Mary Beth's encaustic collages are happy and alive with passion! Visit her blog here: mbshaw.blogspot.com.

Front Door
14" × 12" (36cm × 28cm)
Encaustic medium, encaustic paints, powdered pigments, oil stick, collage items: patterned tissue, decorative paper, vintage items on Claybord

Much of my work is introspective, almost as if my journal pages jump from the page and transform themselves into finished artwork. In this encaustic painting, done about the time of my birthday on 7/07, I was thinking about the future and the pattern piece "7 Front A" really spoke to me. In the painting, this collage element turned into a door questioning me about the direction of my life. "Front A" referred to the first part of my life, and I was left with an internal query as to whether this was an entry or an exit door.

The tissue components contain words that also influence the tone of the piece. Although some of the words are intentionally hidden by paint, I can see the words *Go, Live, Discover, Purpose, Love*. Perhaps I instill my art with too much meaning, but these words speak to me like magnetic refrigerator poetry.

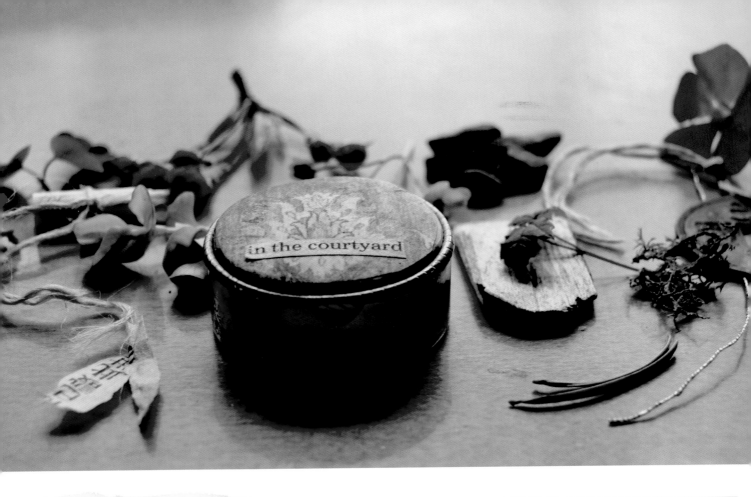

IN THE COURTYARD

Little tin boxes make great homes for found objects, especially when you use them as places to hold treasures. Among the many things I collect are small pillboxes or compacts. This one was particularly lovely because of its size and depth. I had found and cut out the text, *in the courtyard*, earlier and decided this little round box was perfect to house small findings from my back patio or courtyard.

Sometimes I love to lift open the lid of this silver box and lay out onto my desk the bits and pieces nestled inside it. Today that is just what I did. Because the bits and pieces inside it were bedraggled, I decided to go outside to collect more tiny bits reminding me of spring to put inside it and freshen it up.

Of course the tiny green leaves and flowers won't last, but the red crabapple buds will, as will the little rocks and scraps of paper and thread. There is one item in this small box that will never be replaced: the charm that was part of a wind chime I inherited from my mother. One winter the chime broke apart in a snowstorm and the little charms ended up all over the gardens. I often find them when I am working in the soil. I still remember the sounds it made, like my mother's beautiful voice with her elegant English accent.

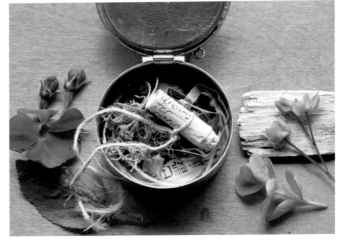

CHAPTER 9
Collage with Metal

I wish to live a life that causes my soul to dance inside my body. »»» **Dele Olanubi**

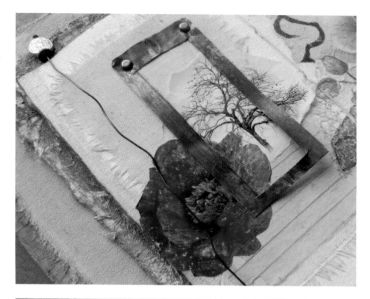

I love to go to junky antique stores and find rusty tins. Often I take them apart and flatten them out. Sometimes I use them as windows, frames or surfaces for smaller collages or covers for books.

Metal makes a beautiful surface to collage on as well as being great to attach onto heavy pieces of paper or wood. The scratches on a piece of vintage brass or copper add so much interest and speak of another time and place.

When you use metal in your collages and paintings, do you think about how you are adding a part of the earth to your art? I think a lot about the five elements of the earth, and I love the ancient Chinese Taoist philosophy that everything in life is made up of a combination of the five elements: Fire, Earth, Wood, Metal and Water. I try to incorporate these elements or energies into my collages, either with objects or something that is representative of each one.

Rusty tin is a wonderful metal to use in collage—the older and more beat up the better. If a piece isn't old, you can always tarnish it yourself with Maid-o'-Metal or liver of sulfur. Sanding metal pieces on the surface to soften the edges is another way to add character, but because metal edges can sometimes be sharp, keep your tetanus shot updated!

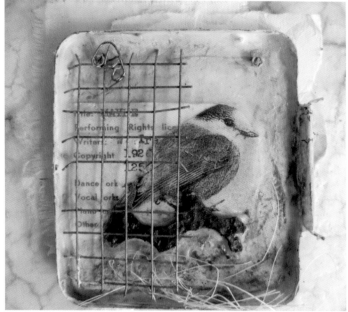

I love to use brass and copper sheets, usually 36-gauge. They are soft enough that you can engrave into the surface, and because they are thin you can cut windows out of them. To do this, fold a sheet in half and cut the shape out of the middle, just as you used to cut out hearts for Valentine's Day.

Matte medium works very well on metal surfaces to adhere images or pressed plants. And a few layers of bees-wax can complement your piece and add a different texture.

Task

Go on a treasure hunt in a downtown neighborhood or even better, when you are on vacation. Find an antique warehouse or shop. The dustier and more crowded, the better! Go on a search for metal tin boxes, even as small as an old aspirin container.

Find at least three to five little tins. Take them home, wipe them out and arrange them on your worktable. Collect some images or objects that will fit snugly inside each tin box and take a photo of this arrangement. Print it out and use it for a page in your art journal.

Today on My Worktable...

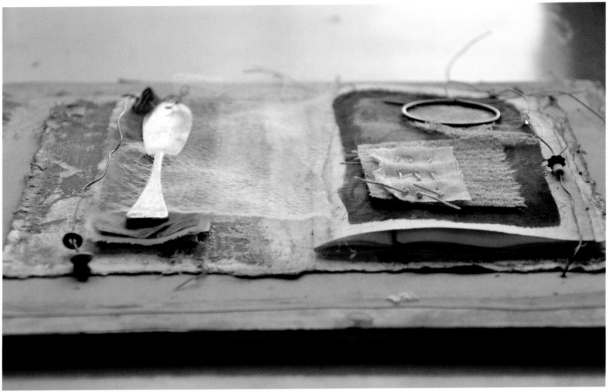

As I arrange new objects on my worktable to inspire me, I am thinking about what new collage I'll make for this chapter, knowing that this will be my last art piece for this book and feeling excited about my ideas.

Ask her what she craved and she'd get a little frantic about things like books, the woods, music. Plants and the seasons. Also Freedom. »»» **Charles Frazier**

Thinking of this quote, I lay out things that I crave, small objects that I can move around in different ways, each time telling a new story . . . my story of this moment in time in the slanting morning sun.

Here is a list of what I have assembled:

- vintage tin boxes and watch parts
- bits of brass strips
- small flower bud, a withered flower and fresh quince flowers
- portion of a butterfly drawing
- tin plate with slices of lime
- old brass conchos
- old chipped garden flag
- magazine scrap

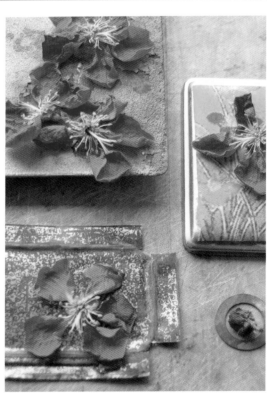

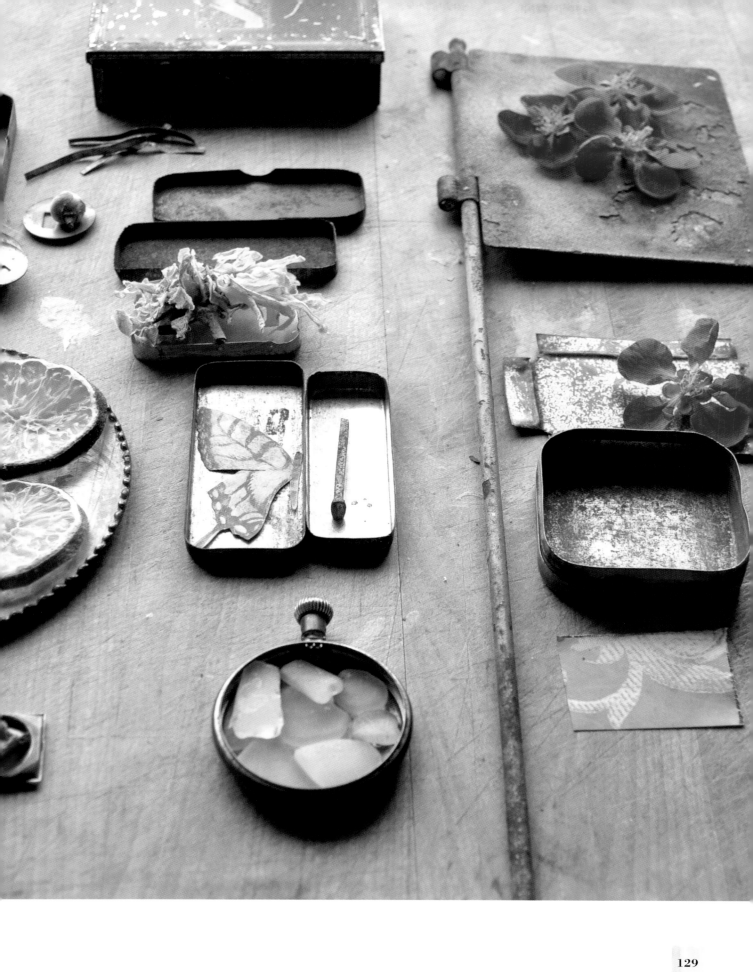

Inside a Butterfly's Dream

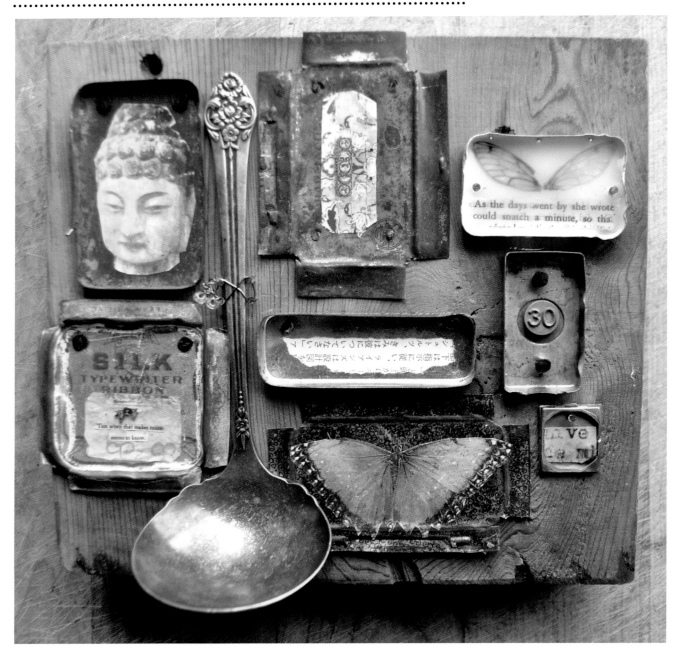

I have wanted to name a collage or a workshop this title ever since I found it and cut it out of a book. I can't remember what book it was, but the images it suggests are intriguing to me.

Butterflies are a timeless part of our earth, and where I live, we see them often. If butterflies dream, what do you think they would dream about? What do they symbolize to you?

As you work on this challenge, think about butterflies and what they might see as they journey from place to place. Your images might be smaller for this collage as mine are, so they can be placed inside the little vintage tins.

What You Need

...

acrylic paint, heavy bodied, brown

drill, small bit

hammer

images

metal shears or a sturdy pair of scissors

nails and tacks

paintbrush, small

permanent pen

sandpaper

tin boxes, small, assorted sizes

wire, 24 gauge (or whatever you have on hand)

wood block, approximately 8" × 8" (20cm × 20cm)

Metal Possibilities

Look around your house and keep an eye out for little
metal treasures when you're out on the street. Here
are just some of the metal objects you might want to
consider using in your collages:
• old nails, especially square-headed ones
• vintage keyholes and drawer pulls
• old watch parts
• recycled jewelry
• vintage tin boxes, whole or taken apart
• old keys
• washers
• tie clips
• wire, different thicknesses
• brads, tacks and rivets
• small picture frames
• brass, silver or copper plates or trays
• screens or mesh
• hinges
• decorative pieces

1 Play with the arrangement

Gather together some little, old tin boxes. If they
are too shiny, sand them lightly. Images will stick better
to them this way, and the sandpaper makes interesting
scratch marks.

Lay out your boxes and any other found objects,
and play with the layout until you have an arrangement
you like. It's helpful to snap a picture of the arrange-
ment with your phone, making it easier to reassemble
and attach the pieces.

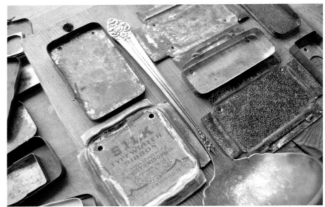

2 Flatten some of the tins

If you want to flatten out a tin box, cut a slit at the corners and pound it out with a hammer. After I cut the slits I usually straighten out the edges so the corners are right angles, but that is your choice. Use sturdy scissors for this or metal cutters. Notice how the "Silk" tin looks in the next photo after I had flattened it and how part of it is still raised in an interesting way.

3 Create holes in the metal

Use a small drill or a hammer and nail to precut holes in your metal boxes. I eyeball mine, but if you need to, you can use a ruler to measure. I also mark where I want the hole first with a permanent pen.

4 Begin attaching the components

Reassemble your layout and look at your design again. I felt mine was too crowded, so I moved things around. I also substituted some pieces for others on the lower right corner. After you have a design you like, begin attaching your pieces to the wood with small nails and/or tacks.

5 Add age to the tacks

Dab a bit of heavy-bodied brown acrylic paint on some of the nail heads to make them blend in and look older.

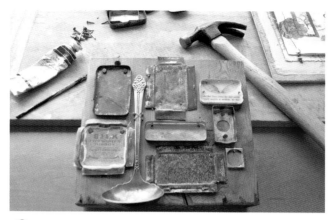

6 Be creative with attachment

If you are attaching something like a spoon, consider using wires and nails to hold it in place. Mark your holes first, hammer in the nails, insert the spoon and wrap around it with wire in an interesting way.

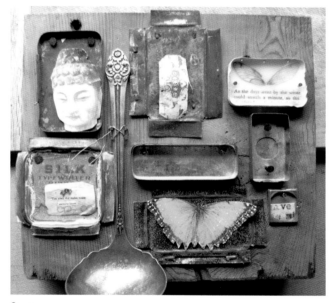

7 Try out images

Now that your pieces are all assembled and connected to the wood, search through your boxes and baskets for images that you might want to use as focal points. You can also look though your own computer photo albums, like I did, and print your images out to size.

Note to Self

What is it that I believe in? Of course, there are big things, love for my family and friends. And I believe in my spirituality, that my home is my refuge, in being an artist and teacher and being true to myself.

But today I made a different list, not a deep list but a more whimsical one!

I believe that spring comes to us each year to breathe warmth into our souls.

And that with the awakening of the world our creativity reawakens as well.

I believe that when dandelions set their seeds free, hundreds of smiles fill the faces of little children all over the world.

That when a dragonfly lands on you while you garden, she brings a message of hope and wonder.

And if you fall asleep to the sounds of wind chimes, the next day you will awaken with a poem in your heart.

I believe in the worms in my garden, knowing how rich they make the soil.

And that the pine trees behind our house whisper prayers of sweet dreams to the river every night.

I believe that if you gaze down into the blue-sky water of a birdbath, it will hold on to your wish until it comes true.

And that when plum blossoms fly through the air in the moonlight and carpet the ground, gladness and peace will fill your dreams as you sleep.

Windows on My World

Outside my windows is a world of color and sunlight that in just a few weeks will be a shady oasis, covered by the lush branches of our trees and the pines that grow beyond. Everywhere are sprinklings of flower petals, and it is as if the flowers are having a garden party.

These are the days it is wonderful to paint and collage outside in the sun or the shade or halfway in between. I like to sit under the yellow umbrella at the round table under the maple trees. I can see and hear inspiration everywhere, from the birdsongs and breezes that fill the air, to the sound of the water fountain and bursts of color from the spring flowers.

Task

If it is a warm day, take a small bundle of art supplies outside: a paint box, paintbrushes and a dish of water, some scraps of paper, some matte medium, and don't forget your art journal! On a fresh page, collage and paint the colors you see around you. With a pencil, make a list of these colors, and paint over your words with a skinny paintbrush. Rub some flower petals or leafs onto your page and label what plant the color came from. Even the soil in your garden can make a beautiful brown when you rub it on paper.

Karen Cole

··

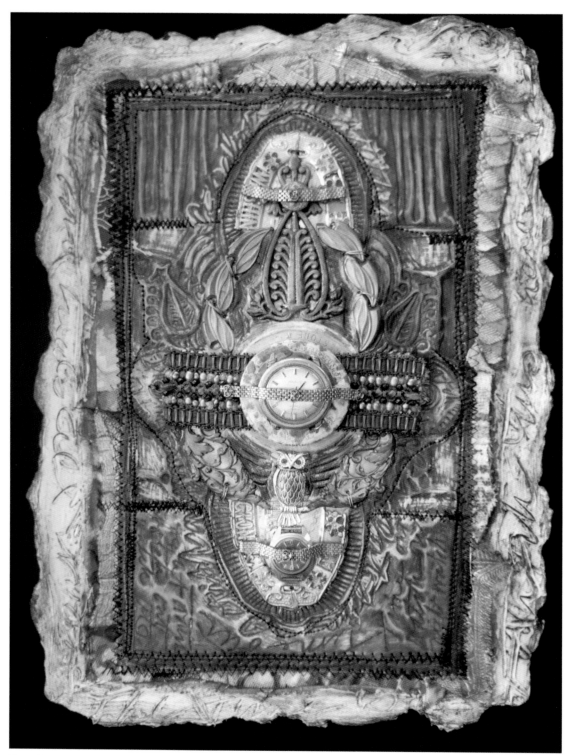

Time Flies
14" × 11" (36cm × 28cm)
Watercolor paper, vintage found objects, acrylic paint, heavy gel medium,
copper wire for attachments, epoxy, vintage fabrics, thread, colored pencils
on 36-gauge copper sheeting

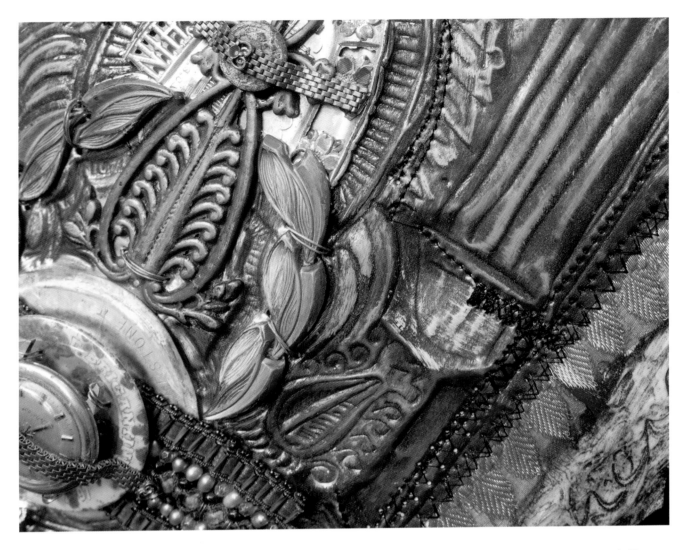

When we were young, life was scheduled to begin tomorrow, next week, next month, next year, after the holidays . . .

Then suddenly we are older. We find that our scheduled life may not have arrived. What are we doing? Where did the time go?

It flew by.

Our faces are marked with lines. Is that my knee with arthritis? Everything seems out of focus. Can't quite see so well

We put on our glasses. Those facial lines, lines that have been put there with love, laughter, suffering and tears. They are so beautiful! We have had the time of our lives! I have had the time of my life!

These are things that have been inspiring my work. The art of aging. The beautiful blue-green patina on the watches in my piece is the starting point. These old broken watches and some of the other vintage pieces on this collage/assemblage are so beautiful, I knew they would become the central focus from which I would draw, emboss, paint and stitch. Live … an homage to the art of aging gracefully.

Karen has a fascinating way of collaging and stitching together copper foil, fabric and found objects. See more on her blog at karencole.blogspot.com.

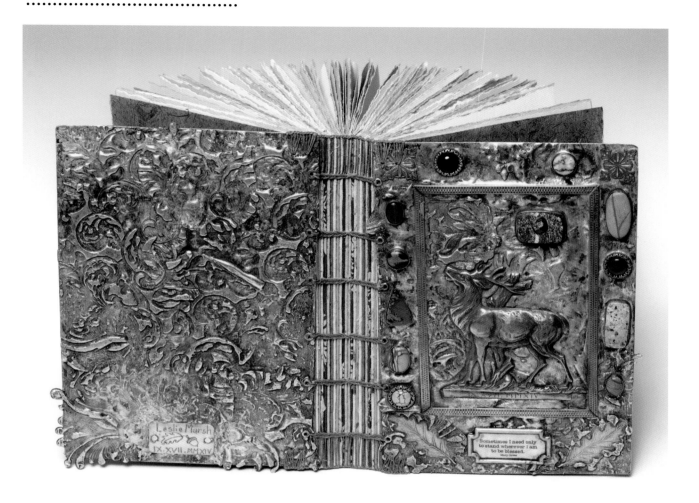

Stand Wherever I Am
6" × 9" × 2" (15cm × 23cm × 5cm)
Lead-free solder, copper and brass embellishments, Ingres antique paper,
assorted handmade papers, waxed linen thread, resin, stones: carnelian, wood
and red creek jasper, turquoise, garnet in schist, chrysocolla, black onyx, quote
by Mary Oliver on 22-gauge brass sheet

Edith Lovejoy Pierce wrote, "We will open the book. Its pages are blank. We are going to put words on them ourselves. The book is called Opportunity and its first chapter is New Year's Day."

I have felt this way about unmarked books since I was a child toddling off to school, confident in the opportunity my empty notebooks promised. Blank books and journals fill an entire shelf in my den because I still believe in the power of a clean page.

A perfect volume of life's possibilities should be protected between grand metal-worked covers, just as certain manu-scripts created during the Middle Ages (mostly those made for royalty or God) were housed in an opulent framework of gold and jewels.

Stand Wherever I Am was inspired by these treasure bindings. The elk on the cover represents determination, grace and gentleness. The stones set around it were chosen for their inherent beauty; however, it has been said that their metaphysical properties can protect, inspire and nurture. What writer couldn't use a few of those qualities when faced with a blank page?

This book was bound using Greek binding.

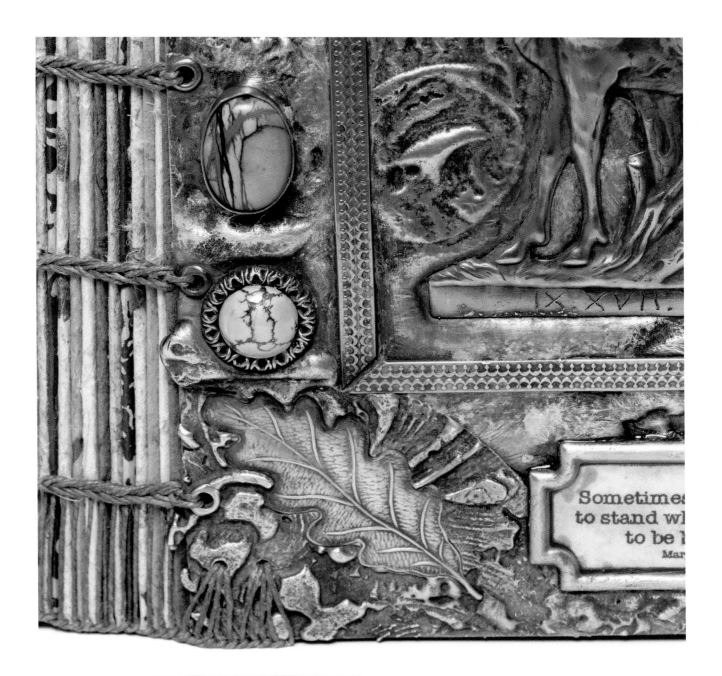

Leslie is an amazing and lovely artist who makes exquisite artist books. You can see more of her work on her website: leslie-marsh.com.

Index

acrylic glaze, 40

adhesives, 6, 14, 15, 29, 43, 60, 90

aging, 127, 132, 137

Apter, Seth, 62–63

attaching, 7, 90, 132, 133

Avineri, Orly, 76–77

background, 25, 59, 104

balance, 12–15, 44

beeswax. See wax

brads, 90

brayer, 15, 74

Brooks, Rebecca, 66

Bruhn, Ro, 108

Bunsen, Elizabeth, 32

butterflies, 19, 109, 130

cleanup, 6

Coe, Annie, 50–51

Cole, Karen, 136–37

color, 6, 25, 98–113

complementary colors, 103

composition, 43, 59, 104

contrasts, 69

Crock-Pot, 118

Davidson, Sharmon, 46–47

depth, 73

details, 15, 74

Distress Ink, 15, 90

dyeing techniques, 102

embellishments, 30, 91, 121

encaustics, 6. See also wax

fabrics, 7, 24–37

fading, 72

Fishburn, Sarah, 80–81

fixative, 6, 59, 90

focal points, 14, 30, 44, 57, 104, 105, 121, 133

found/collected objects, 6, 54–67

gesso, 25, 73, 74

Giglio, Caterina, 16–17

glazing, 40, 43

Gordon, Robyn, 67

hair spray, 6, 59, 72, 90

heat gun, 120

Henkel, Kim, 94–95

Hilvitz, Stephanie, 109

holes, 44, 132

home, 18, 92

imagery, 7, 68–83

inspiration, 10, 40, 56, 128

Instagram, 124

interest, 15, 44, 73, 91, 102

Kilyfoyle, Sharon, 102

LaFazio, Jane, 52–53

layering, 105, 118, 120

Lehrer-Plansky, Mary Ann, 33

light, 56, 98

Marsh, Leslie, 98, 138–39

materials, 6–7

matte medium, 6, 15, 30, 60, 74, 127

metal, 126–39

mica, 97

Mills, Bridgette Guerzon, 115, 124

nature, 85–97

Neubauer, Crystal, 20–21

outdoors, 44. See also nature

PanPastels, 6, 121

papers, 7, 15

colored, 9

parchment, 104

textured, 8–23

tissue, 104

watercolor, 15, 43, 104

pastels, 59

photos, 68–83

Pierotti, Joanna, 82–83

play, 56

pressing technique, 11, 87

rust, 127

sanding, 14, 29, 127, 131

Scott, Lorri, 36–37

Seggebruch, Trish Baldwin, 115

sepia ink, 40

Shaw, Mary Beth, 125

Shay, Bee, 96–97

stamping, 90

stencils, 75, 90

stitching, 7, 37, 38–53. See also fabrics

surfaces, 7

tarnish, 127

tearing, 14, 102

texture, 25, 121, 127

textured papers, 8–23

threads, 121

tin boxes, 55, 126, 127, 131, 132

tinting, 15, 73, 121

tools, 6–7

Verdugo, Tracy, 110–11

Watson, Donna, 22–23

wax, 114–25, 127

wire, 6, 57, 60, 91

wood, 120

Zaheer, Jill, 112–13

Dedication

I dedicate this book to my loves: Jim, Amanda and Christopher. You three are the lights of my life. You have filled me with joy, listened to my dreams and shared your own dreams with me. I am blessed to love and be loved by you.

Acknowledgments

To my contributing artists: Each one of you has touched my heart. Over the last year (or even longer) I have read and reread your stories and gazed at your artwork with wonder. Each time I have felt humbled that you have shared with me your own truly unique Collage Story.

A very special thank-you to Tonia Jenny for your never-ending creativity, kindness and hard work. You listened to all of my ideas and helped make my dreams come true. You and this book are so very close to my heart!

And to Rob Warnick, Brianna Scharstein and the rest of the team at North Light Books: for taking my art, my photographs and my words and putting them all together in the creation of this beautiful book.

To my mother: I see parts of you all over my home and gardens. I see you in the red-tailed hawk that soars through the skies. And I see you in my art. Thank you, for being my first teacher. I know somewhere you are painting on top of a cloud in Heaven.

To all my amazing teachers: Thank you for believing in me and my art and for the inspiration you have given me.

To my students: Thank you for letting me be your guide in my classes and workshops. Each one of you has guided me in return. I have loved learning and growing alongside of you.

To my friends and family, whether you are across the world or down the street, thank you for the sharing, the trust, the smiles and the laughter. I love you all.

And to you who are reading this book: Keep creating, keep learning and growing and keep telling your own stories through your art.

In your light I learn how to love.
In your beauty, how to make poems.
You dance inside my chest where no-one sees you,
but sometimes I do
and that sight becomes this art.
»»» Rumi

North Light Books
An imprint of Penguin Random House LLC
penguinrandomhouse.com

Printed in China

10 9 8 7 6 5

ISBN 978-1-4403-4050-5

Edited by Tonia Jenny
Cover designed by Brianna Scharstein
Interior designed by Rob Warnick

Metric Conversion Chart

To convert	to	multiply by
Inches	Centimeters	2.54
Centimeters	Inches	0.4
Feet	Centimeters	30.5
Centimeters	Feet	0.03
Yards	Meters	0.9
Meters	Yards	1.1

About Roxanne

I help others express their unique beauty by illuminating the stories of who they are in quiet moments, in harmony with nature and as the creative voice of what's sacred.

I am an artist who is constantly struck by the beauty and mystery of the world. I live at the base of the Cascade Mountains in Southern Oregon. From my home and my studio, River Garden Studio, I look down on the Klamath River. Overhead is the Pacific Flyway—an ancient skypath of thousands of migratory birds. This is my inspiration: the natural history and the nature and wildlife of this land, especially birds and insects. These are an integral part of my creations.

As a full-time artist, I teach and design art workshops throughout the year and have had my art shown and published nationally in many magazines and books. I also design stencils for StencilGirl Products.

Book arts, art journaling, encaustic painting and collage are my very favorite ways to express myself. I have recently discovered cold wax painting and am very excited about it as well!

I love to combine images that tell a story, convey an emotion or somehow have a message of timelessness. I am entranced by how one moment can be forever remembered; something as simple as an image of a nest, a songbird or something tangible and small as a found stone, a piece of wire or string. To me, adding a found object to a collage or painting connects us to the world and gives a sense of place and time. This not only describes my work as an artist, but the message in all of my teaching.

Where to find me:
rivergardenstudio.typepad.com
facebook.com/roxanne.evansstout
facebook.com/RiverGardenStudio
stencilgirlproducts.com/category-s/1907.htm

Photographs by Amanda Kotler at Eden Valley Orchards in Southern Oregon.